MARKETING AND SELLING
BLACK & WHITE
PORTRAIT PHOTOGRAPHY

Helen T. Boursier

AMHERST MEDIA, INC. ■ BUFFALO, NY

Published by:
Amherst Media, Inc.
P.O. Box 586
Buffalo, N.Y. 14226
Fax: 716-874-4508

Publisher: Craig Alesse
Project Manager: Michelle Perkins
Senior Editor: Frances Hagen Dumenci
Assistant Editor: Matthew A. Kreib
Copy Editor: Paul E. Grant

ISBN: 1-58428-015-8
Library of Congress Card Catalog Number: 99-76253

Printed in the United States of America.
10 9 8 7 6 5 4 3 2 1

Notice of Disclaimer: The information contained in this book is based on the author's experience and opinions. The author and publisher will not be held liable for the use or misuse of the information in this book.

ABOUT THE AUTHOR:
Helen T. Boursier has operated a portrait studio on Cape Cod since 1983 with her husband of twenty years, Michael. She works exclusively with black and white portraits of families and children. Her trademark look includes lightly hand colored wall portraits on artist canvas. Helen has authored a dozen other photography books, and has lectured on photography across the country and around the world.

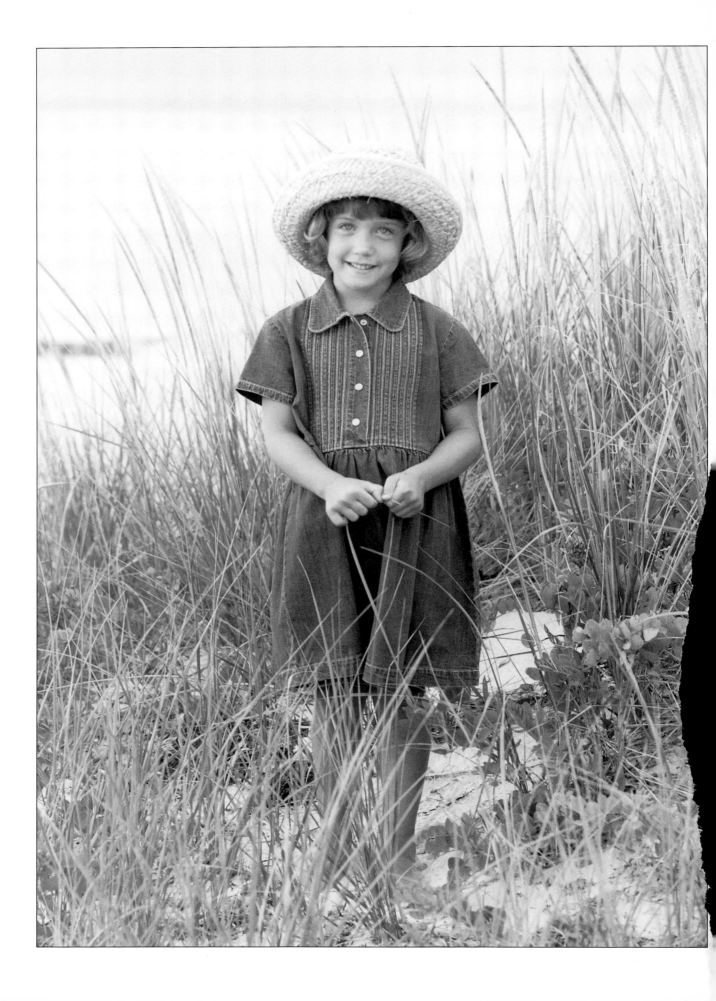

Table of Contents

INTRODUCTION

"Your passion sets the
mood for success..."

It takes much more than a love affair with black and white portraiture to ensure business success. Your passion sets the mood for success, but your basic business practices ultimately determine whether or not you succeed.

Boursier Photography opened on Cape Cod, Massachusetts in 1983 to photograph weddings using color film. By the late eighties, the studio had gradually evolved to photographing families and children using only black and white film.

To successfully make the transition from one very different specialty to another, we applied sales, marketing and business skills. This ensured we could photograph the black and white images we love while also earning a living that would make our hard work worthwhile. As I have said to my seminar audiences for years, if you cannot figure out how to earn a decent living doing photography, you should give it up and find a "real job" that inevitably is a lot less work but pays a lot more money.

Marketing and Selling Black & White Portrait Photography will show you how to take your passion for black and white portraiture and turn it into a profitable business. You will be happy to earn a living doing the work you love to do. Also, your clients will be thrilled that you are professional enough to keep your business successful. When you know what to do to keep your doors open for business, your clients benefit by being able to hire you year after year for the beautiful photographs that you love taking and they love buying.

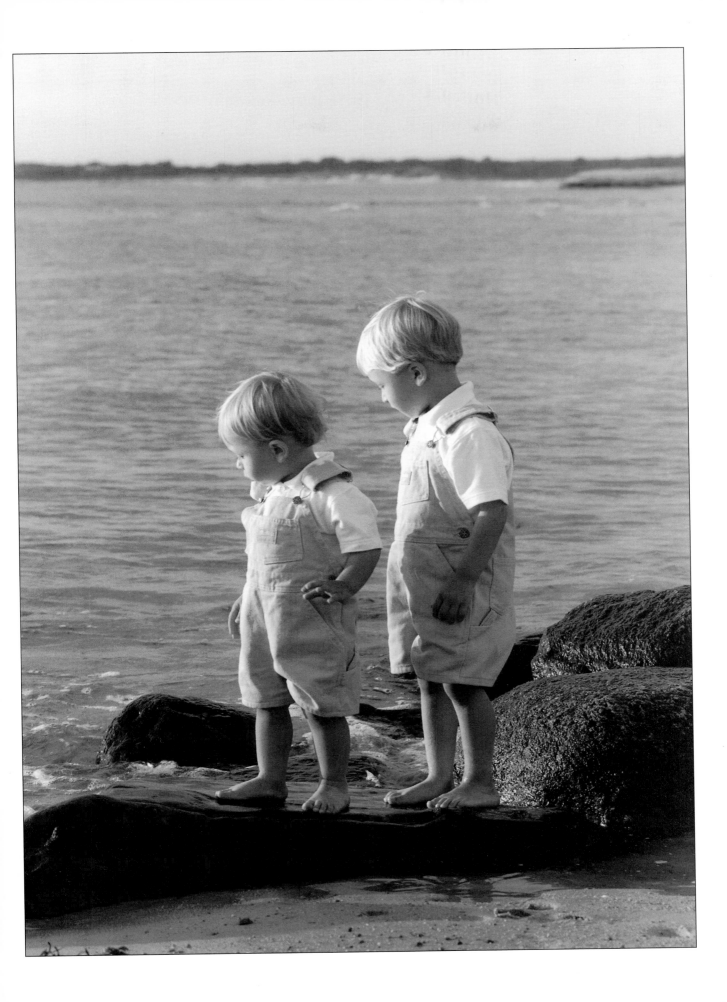

CHAPTER ONE

"Like Attracts Like"

"Like attracts like" simply means that people are comfortable with others who have similar interests, styles and tastes. You can see this selectivity evolve in your own children. Pre-school children are happy to play with everyone in the class-room. They just want to play!

As these children grow up, they gradually choose friends who share like interests. By the time they are in high school, they have formed strong cliques and will rarely look outside of this tightly bonded group.

In fact, during our son's senior year, he wrote a thesis paper on the importance of these cliques in "identifying peers." Attraction to similar likes does not stop when you mature into adulthood. With limited resources of both time and money, the only possible way to go through life is to spend both where you will enjoy each the most.

"...design your studio to attract the types of clients you want to attract."

The logical response to the "like attracts like" rule is to design your studio to attract the types of clients you want to attract. When we opened our first studio in a classy office condo complex, some photographer friends said they would never feel comfortable coming to us as clients because the studio decor was too fancy. But, of course, the reverse held true for us. We would not have gone to their studio because it was too casual.

We designed our studio to take advantage of the simple fact that customers like dealing with successful businesses because, they rationalize, if the business is successful then it must be good. Being successful does not automatically happen the first

Humble beginnings... our original home studio was in the "ground level" of our split floor ranch home. No matter how you worded it, the studio was crammed into a small basement bedroom.

The office condo location looked like a home on the outside because of the Cape Cod shingles and building style (above), but the inside was a crisp office environment (right).

When we moved back to a residential location, we combined the professional look from the office condo with a relaxed feeling provided with a home setting.

year you hang your sign out and declare yourself open for business. That is where the "fake it 'till you make it" philosophy comes in handy.

Put your money where your clients see it. We often lecture to photography conferences across the U.S. and around the world. When we were visiting Italy, one of our host families had furnished their home with designer names. Even the lamp was crafted by a famous artist! When we visited their studio the next day, located in the heart of a busy shopping district, I was surprised to discover that they had put all their money into their home and none into their studio. It was as if they had put all of the leftovers from the house at the studio.

Their business would have prospered more quickly had they reversed their furnishings. When you are building a business, there is nothing more important than putting your best foot forward, or in this case, your best furniture and fixtures.

When we relocated to our residential studio in 1999, we consolidated all the furniture between the "old studio," the house and the new wing for the new studio. After fifteen years of building our business, we finally had more good furniture then we knew what to do with.

We reupholstered all our favorite and best furniture from the "old studio" to bring to the new. Then we shifted some of the extra furniture from the old studio to the living room of our home, the living room furniture shifted to the TV room, and the TV room sofas shifted to our teenager's bedroom.

Power Through Positioning

In keeping with the expression "put your money where your mouth is," positioning means putting your business where you want to get your customers. The physical location of your business should suit the clientele whom you want to serve. Figuratively, you want the image of your business to match the mental picture your type of client would get when thinking "portrait photographer."

Right after we had shifted everything around, some friends commented that our home had never looked so nice. "No offense. Your house has always looked nice, but not this nice." We have always put our money where our clients see it. Even now, the nicest rooms in our home are in the studio wing. In the old days, folks would have called it the "company room." In our case, that company happens to be our clients.

Dress for success and drive a classy car...

"Like attracts like" doesn't stop with your studio decor. You are part of the equation too, and you need to dress and drive the part. The key is to blend in with your target clients. If your studio is located in the heart of New York City, you are going to need to dress totally different from the studio located in a Colorado ski resort.

Relaxed dressing is an integral part of Cape Cod living. Dressing to match your client base will make both you, and your clients, feel more comfortable.

I like dressing up. When we first opened our Cape Cod studio, I wore all my two-piece suits and panty hose and heels every day. Every now and then a client would apologize for how they were dressed. I realized I was making my clients uncomfortable because they were on vacation and headed to the beach or golf course. I was dressed like a banker, but they were dressed for rest and relaxation. I toned it down to look professional, but to better blend with my tourist clientele. Now during spring and summer, I wear long sun dresses with flat sandals. During the fall, I wear corduroy slacks and a sweater or blazer. I wear quality accessories for all three seasons.

Dressing down does not mean dressing poorly. Have you ever noticed the executive travelers at the airport? They might be wearing blue jeans on their way home from a business trip, but they put the rest of the pieces together so they look like the successes that they are. I might wear shorts when I photograph a session at the beach, but they are crisply pressed shorts with a linen top, silk scarf and my favorite gold jewelry accessories. In fact, it is not uncommon for my clients to say, "You look like you could be in the picture with us."

How you keep your car is part of the image package you present to your clients. If your client never sees your vehicle, you can drive a beat up old jalopy that has piles of soda cans, candy wrappers and fast food trash cluttering the floor in the back seat. Just keep your car out of sight from your clients! If you are going to fake it until you make it and put your best foot forward, then you need to drive the classiest, cleanest car can you afford.

Look at your car as your calling card. We have three vehicles parked in our driveway, and each one sets a definite mood: white pickup, green conversion van, white four-door luxury car. Which one would you want your wedding or family portrait photographer to arrive driving? Which one says, "I bet you this person knows what they are doing with a camera!" Objectively, the car has nothing to do with whether or not you know how to take a picture, but it still sends the message to the client that you do!

You have one chance to make a first impression. Clean and neat is part of the package. My car is four years old, but people consistently ask me if it is new. My partner/husband keeps the car spotless, both inside and out, because it sends the message to our clients that we take time to care for all aspects of our business.

Hide Your Age with Clothes

Sometimes you will be much younger than your client, and people tend to lose confidence in someone who looks too young to be successful. Dressing smart is imperative to gain and maintain credibility with your clients during the shoot as well as later at the sales session. The older and more successful my clients are, the better I dress.

Fake it 'till You Make it

Customers like dealing with successful businesses based on the simple logic that, if the business is successful, it must be good. It isn't likely, though, that you jump in feet first and immediately open a "successful" studio. That's where the "faking it" comes in. Dress sharp, drive the nicest car you can afford, and put your money where the customers can see it.

On a similar note, when you pull down a tray on an airplane and there are coffee stains on it, you can't help but wonder if they are not taking care of the inside of the airplane. Does that mean they are also not taking care of the engine either? When the part you see is spotless, you feel confident that the part you don't see is spotless too!

Put your money where your clients see it, dress for success, drive a classy car and always remember that like attracts like. The combination helps you to position your business so you attract the clients you like to work with.

"Put your money where your clients see it..."

Remember to design your studio to attract the types of clients you want to serve. This includes where the studio is located, how you dress, and what kind of car you drive. These are all factors in how you position your business.

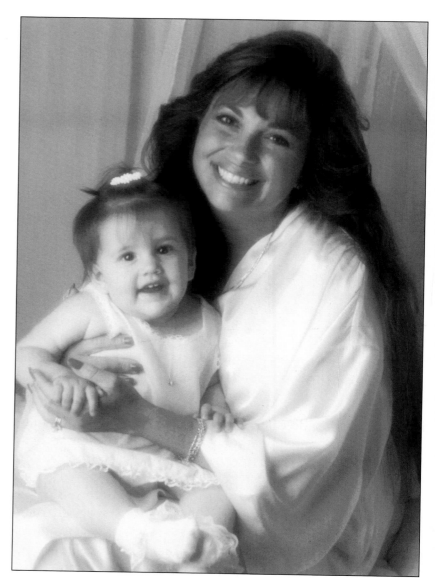

CHAPTER TWO

Establishing Your Style

The essence of your studio is the style of portraiture you offer. There are two very different approaches; you can be a specialist or a generalist. The specialist works within a limited area, much like a doctor chooses to specialize in pediatrics or dermatology. The generalist is like the family physician who takes care of a wide range of medical problems. There are pros and cons to both.

Generalists have a wide market area both for the variety of products they offer and the types of film and styles within each portrait category. There are very few jobs they turn down, because there are so many types and styles of photography that they offer. Specialists are going to attract a much smaller percentage of people from within a geographic area because fewer people are going to be attracted to the more limited offerings. They turn a lot of jobs away because they do not offer the style or product the client desires.

On the up side, specialists tend to be much better at the limited product they do offer. By the very nature of working full-time in a more limited field, they become much better at their craft. Think about it. Compare a generalist photographer who photographs half a dozen sessions a year in black and white to a specialist who photographs two hundred sessions a year in black and white. Whose skills will improve the most? The one who does six sessions or the one who does two hundred? There is a lower risk being a generalist because there are so many other types of photography to fall back on if one does not work out. However, the higher risk for the specialist often nets a higher profit. Plain and simple, when you are better at what you do, your product merits a higher price.

"The essence of your studio is the style of portraiture you offer."

Boursier Photography opened in 1982 to photograph weddings full-time using color film.

"Most specialists evolve from first being generalists."

A studio that specializes in a specific style understands the creed, "jack of all, master of none." Instead of doing a little bit of a lot of different types of photography, the specialist chooses the areas that he is most passionate about and works exclusively within those areas. Most specialists evolve from first being generalists. Boursier Photography is the perfect example.

We opened our studio in 1983 to photograph weddings, and we used only color film. Because we were a struggling new business, we also took any photography assignment that came our way. As we gradually gained experience and expertise, we started to discontinue some of the types of photography that were not our favorites. We also started offering the black and white photography that we had always loved.

During our early years, we photographed a limited number of children's portrait sessions, all in the studio and all in color.

While we trying to get family groups to be photographed outdoors instead of the traditional indoors, we typically did both for every client. We started in the studio with the formal session (right), and then went to a park or beach to complete the sitting (below).

While we were gradually phasing out our weddings, we were increasing the marketing for families and children.

We followed the same procedure when we phased out of color and into black and white. When we first introduced black and white to our clients, we basically ran a roll of Kodak Tri-X Professional film through the camera on every family portrait session whether they asked for it or not. As we gradually had more and more practice and more and more samples, clients began requesting black and white.

Again, gradually, we attracted clients who definitely preferred black and white so there was no need to offer color. One year at Christmas, when the color lab deadlines came for all color enlargements, we took down all our color samples and replaced them with black and white. We never put the color back on the walls. The evolution process had been so gradual that our clients barely noticed. Over an eight-year period, we had very slowly, but very specifically, made the transition from color to black and white.

Making the deliberate decision to offer black and white is an important element of your studio's signature look. Your actual photographic style completes the equation. During the beginning years, it is natural to experiment with a variety of techniques and styles. Don't just copy for the sake of copying. You must develop a unique personal style. As you adopt the bits and pieces of all this experimenting, you create a certain look that is distinct and as unique as you are. The signature look sets you apart from the masses and works as a magnet to attract clients to you.

I have two distinct looks. The majority of my work is full frame faces. I literally fill the frame of the camera with my subjects, whether they are individuals of children or large family groups. I include just enough of the setting to give viewers a sense of the location, and then let the people tell the rest of the story.

Instead of great scenery, I go for great expression. I particularly love laughter. There is such a wonderful feeling of joy when you see a group of children or adults laughing. A total stranger might view the portrait, but he will still be inclined to smile because he knows he is looking at a group of people who are full of joy. Pride and tenderness are two feelings I also enjoy capturing in my portraits. You notice pride in the eyes, particularly of a parent or grandparent who is

Have Fun & Experiment

One fun thing about photography is experimenting with new techniques. There are so many different options to explore with black & white film. Go ahead — try it out! And keep trying new things. This is the best way to keep those creative juices flowing and to increase your love of photography.

We photographed this couple's wedding in color, but they made the transition with us and bring their children in for annual portrait updates in black & white.

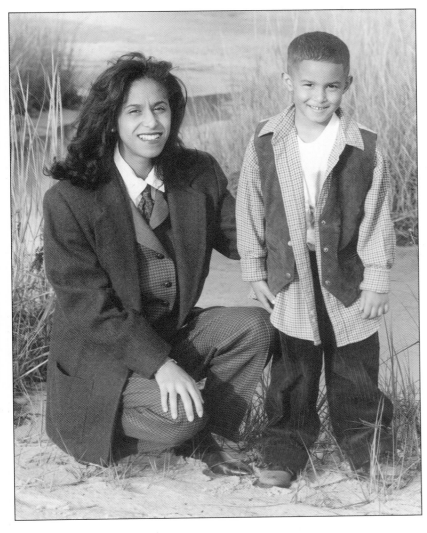

surrounded by the family members they love. Capturing the tenderness between a mother and a daughter or a husband and a wife is a priceless way to help my subjects remember the feelings they have for one another.

The second style I love is illustrative. Instead of the subjects looking at the camera, they are involved in an activity with the environment or with each other. The viewer feels like they are looking out a picture window and seeing a slice of real life. Where the portraits of faces looking at the camera engage the viewer, the illustrative style lets the viewer sneak a peek at the subjects unaware. You are not meant to see exactly what each subject looks like, but to get a feeling of who they are and what they enjoy doing.

My all-time favorite portrait of our family was taken by Marg and Peter Straw when we were lecturing in New Zealand.

"...the illustrative style lets the viewer sneak a peek at the subjects..."

23

Illustrative portraits capture a mood. They are meant to show viewers a slice of life. Where full frame faces engage the viewer in the subject, illustrative images engage the viewer in the setting and the feeling behind the faces.

The three of us are walking, hand in hand, through a field at their daughter's sheep station. Mike and I are looking at Jason, and he is laughing and looking at the camera. That portrait captures the feeling of our family more than any other full frame faces portrait ever has or ever could. Jason is looking out at the world with the optimism and confidence and joy of a teenager, and we are looking at him with all the pride and joy of parents who are about to launch their son into the real world. A client might look at the portrait and say, "But you can't see their faces." But you cannot mistake the feeling those three people have for each other. Illustrative portraits are about capturing feeling.

Once you figure out who you are and what you want to offer, use your printed materials to convey this message to your clients.

CHAPTER THREE

Paperwork Supports Your Products

Your printed materials should support your photographic style, your photographic medium (i.e. color versus black and white, versus hand tinted black and white) and the clientele you expect to attract.

The most important element is continuity. Choose a color theme, a logo, a type style and a paper stock to use for all the printed materials that reach your clients. This includes letterhead, notepaper, envelopes, brochures, postcards, price lists, mailing labels and invoices.

When we started our studio, we chose green as the accent color because it complimented our color photography. As part of the transition to black and white photography, we switched our business colors to grey letterhead with black and silver accents. I used a bit of lavender to add pizazz and to tie the printed paperwork into the decor color of the studio. I keep only purple ink pens around the studio. One client commented, "I can always tell when I have been to your studio because there is purple ink in my checkbook register."

The printed materials you use to promote your product should do justice to both your quality and your style. When we transitioned from color to black and white, the hardest thing to give up was the mass-produced wallet photographs we used to customize our price lists and product brochures. We used double-stick tape to place the color wallets in various openings on our printed materials. It was quick, easy and inexpensive.

> "The most important element is continuity."

To mass-produce hand colored black and white portraits, we mounted four 4x5 tinted portraits onto an 8x10 board, shot a 4x5 color transparency and sent it to Dynacolor Graphics for mass-produced postcards.

Invest in Postcards

I don't care how much self control one has about not reading junk mail — everyone reads postcards when they arrive unsolicited in the mail. With no envelope getting in the way, it is just too easy to turn the card over and read the short blurb on the back.

To get the best possible reproduction of the hand colored black and white portraits, we switched to postcards. We used them as stuffers in our various brochures and we used them as direct mail pieces to potential clients. No matter how much self control you have about not reading junk mail, no one can resist a postcard. The automatic response is to turn it over and read the short message. Voila! Message sent. Message read. Message received.

Computer technology makes it easy to produce and print catalogs, brochures and assorted client materials. The best part about producing your own materials is that you can generate short press runs to service a particular need. Instead of the huge quantities that you once had to order from a commercial printer, you can run off five copies, fifty copies or five hundred copies. And, you can make corrections, additions and deletions every time you fire up the printer and push "print."

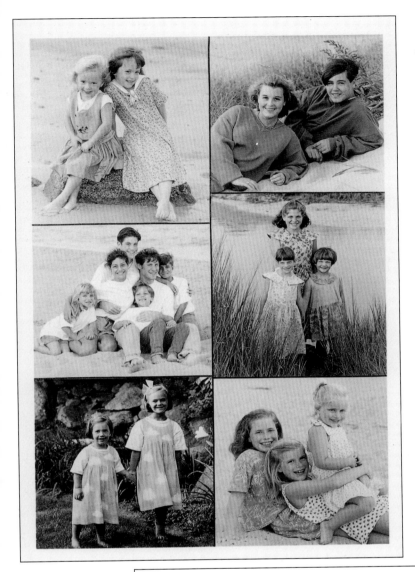

Postcards are great to gradually add to your printed materials repertoire because they are inexpensive and easy to produce. Left: Front of postcard. Below: Back of card.

Our 16-page portrait planning booklet helps clients prepare for perfect portraits.

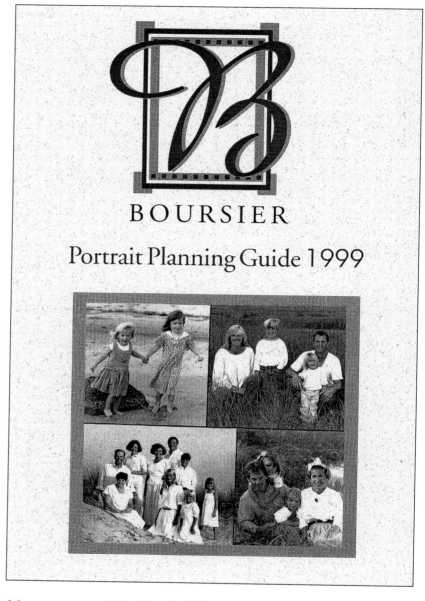

"...the information our clients need to know to help them prepare for a perfect portrait."

My partner and husband, Mike, produces our portrait planning booklet in-house. I write the copy and prepare a rough layout, and Mike does the rest. It was initially labor intensive for him to learn how to use all the programs. Once he had conquered the learning curve, it became as second nature as taking a picture. He uses a Gateway computer and an assortment of software including Windows, Corel Draw, Corel Photo-Paint and Adobe Photoshop. He also uses a Microtek Scanmaker III, a Kodak Digital Camera and the HP Color Laser Printer 4500.

Our portrait planning guide includes all of the information our clients need to know to help them prepare for a perfect

portrait. The guide is sixteen pages, including the front and back covers. It is printed on 8½x11 greystone paper, folded in half and stapled three times on the fold. The color laser printer enables us to easily include samples of hand colored as well as classic black and white portraits. There are also four color examples of finished pieces hanging on the walls in our clients' homes.

The guide opens with an index to the information included and a photograph of myself with a "meet the artist" article. I meet the majority of my clients for the very first time at the portrait session, often at the beach, and this photography and copy about me serves several purposes. First, they know what I look like so they can recognize me when they pull into the parking lot at the beach. Second, the copy provides credibility about my professional background. Third, it explains my passion for portraiture and hints at what to expect when working with me. The combination of the copy and the photograph makes clients feel like they already know me, so we are able to begin the session as friends and not as strangers. The copy reads:

Meet the Artist...

Helen T. Boursier has a passion for excellence, a passion for people and a passion for fine portraiture. She combines these passions to create one-of-a-kind pieces of personal art. Her goal is to create portraits that will bless your lives for years to come and be remembered as one of the best investments you have ever made. Helen works to capture the true spirit of each subject in a "casually perfect" natural pose within a beautiful setting and using natural light. You will be amazed by her energy, entertained by her antics and pleased with her results.

Helen's reputation reaches far beyond Cape Cod. She has authored more than a dozen books, and during the winter months Helen lectures at photography conferences across the U.S. and around the world. She holds a number of professional degrees including the prestigious Master of Photography from the Professional Photographers of America. Helen is the youngest ever to receive the Associate

Guiding Your Clients

A guide, whether it be in the form of a brochure or a simple sheet of paper, should tell everything the client needs to know for a successful session. It should include information about you, your studio, and your photography.

Degree from the elite American Society of Photography, and she is on the advisory board for Eastman Kodak's Promise of Excellence program.

When you want something unique, when you want something special, when you want something to treasure for generations, ask for Helen.

"The guide also includes an overview of what to expect..."

The guide also includes an overview of what to expect when working with the Boursiers. We are very up front with clients about who we are and what we offer because we do not want them to feel surprised later. If they read nothing else in the booklet, this one page will give them a sense of Boursier Photography. The copy states:

- We love people. We love natural expressions. We love black and white. We love surrounding ourselves, both at home and at work, with portraits of the people we love. We are excited about sharing this passion with you.

- All of our images are created in black and white (with the exception of our new Watercolor Portraits). All portraits are made by hand in the tradition of the Old Masters like Ansel Adams. Any coloring is subtly added by hand on an individual basis using an artistic interpretation.

- Your session fee my be applied to any concept (one through four) or toward the purchase of a 14" or larger portrait.

- Appointments are available for sessions and for viewing Monday through Saturday by prior arrangement.

- You are in for a treat when you make your portrait pose selections because we use the technology of projected slide proofs. You will see the people you love come to life on our studio wall. It is the only time you physically must come to the studio, and everyone who wants to be part of the decision making process should plan to attend.

Appointments...

In order to give every client our undivided attention, we are available by appointment each time you visit the studio. Please do not just drop by to try and "catch us" as we will likely be already in an appointment or off photographing on location.

Planning session Date _____ Time _____

Photography session Date _____ Time _____

Slide/viewing selection Date _____ Time _____
Completed portraits are shipped directly to your Home/office immediately upon completion.

East Falmouth - Cape Cod

DIRECTIONS TO OUR STUDIO...

From Off Cape... (points north and west)
 Go to the Bourne Bridge and take Route 28 to Falmouth. Take the **"Brick Kiln Road"** exit and turn left off the ramp. Go through two traffic lights (Gifford St then Sandwich Rd) and turn right at the stop sign. Short jog takes you back to Route 28, where you will turn left. Go about ½ mile and turn right on Acapesket Rd. *(Gas station and fitness center on corners).*
 *Follow Acapesket ½ mile and turn right on Irene (short stockade fence on corner). Go one block and turn left on Carol Avenue. We are the last house on the left (#74). Park in the circular drive. The entrance is under the farmers porch.

From Hyannis/Barnstable...(points east)
 Take Route 28 to East Falmouth. Look for *St. Anthony's Catholic Church* on the left. Then you'll see a *Chinese restaurant* and *fitness center* on the left.. Turn left on Acapesket, follow * above.

Need more directions? - not a worry 1-800-903-3950
-4-

A page from our planning booklet.

- Helen needs the undivided attention of the subjects she is photographing to create the best possible series of images. Other cameras and people are distracting to the subjects and jeopardize the quality of the work, so please keep your 35mm and snapshot cameras in the car until Helen is completely done photographing (and please ask family members to do the same).

- During the photography session, you will find Helen's energy level amazing, her antics entertaining and her enthusiasm boundless. She works fast to ensure everyone has fun, including tots, teens, dads and grandparents. Remember...the key word is FUN!

The remainder of the guide includes information in what I call a "need to know" basis. In other words, in the order the client needs to know the information throughout the portrait process. Page four explains the three times clients need an appointment to meet with us (optional planning session, photography session, slide/viewing session) and gives directions to the studio.

Page five discusses details about clothing, grooming and the timing of the session. It also shows two samples of clients dressed in dark clothing compared to clients dressed in light clothing. Page six explains the difference between a basic session and a prime time session and shows samples of the locations we use for our "basic" session.

The prime time session costs twice as much as the basic for the simple reason that we can do two sessions an evening at one of our local "basic" locations compared to only one session at sunset when the client chooses their special spot. We do not take any more or less images between the two. The rest of the portrait planning guide shows samples of our portrait styles and deals with choosing the completed portraits. (Complete details in later chapters.)

Mike also produces our semi-annual newsletter. Again, I write the copy and Mike does the layout and design to make the piece look professional. The mood of the newsletter is light and friendly. I write the copy as if I were communicating with an aunt or a long lost cousin, and I include both personal and professional information.

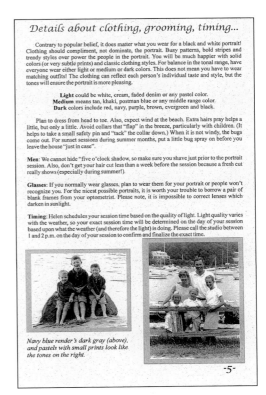

A page from our planning booklet.

"The mood of the newsletter is light and friendly."

BOURSIER PHOTOGRAPHY

1-800-903-3950

Spring 1999 - Newsletter

We've Moved...

Boursier Photography reopens for "the season" at a new location. When Jason entered kindergarten thirteen years ago, we moved the studio from our home to the office condo complex. Now, with Jason graduating from high school in June and moving off to Gunnison, Colorado to attend *Western State University* in August, we are returning to the overall flexibility possible with a residential studio. We are located (by appointment) off of Acapesket Road in East Falmouth.

We used "The Big Move" as an opportunity to pursue excellence in all aspects of our portrait studio. In short, we made all the changes we had been talking about for years. Once builder Michael Davis completed the addition in January, Mike B. did all the painting and landscaping, while Helen worked magic with *fifty yards* of fabric.

Literally everything about the new location is new. New decor colors. New samples. New types of portraiture products. New window for available light portraits. New front porch for a "back-up" location on rainy days. New photography props. New camera. New frame samples and styles. New business logo. New outlook! We can't wait for you to see the end result! To quote Helen, The studio looks, "way cool".

Travels...

Completing the studio consumed most of our time this winter, but Helen still squeezed in her writing and speaking. She spoke at professional photography conferences in Indiana once and Las Vegas twice, and she gave a key-note address at the New England Institute of Professional Photography. Helen is off to Texas at the end of April to teach a week-long course at the Texas School of Professional Photography. Then Helen goes to Dallas to photograph the infamous Zig Ziglar and his family. The portrait will be presented to this world-renowned motivational speaker at the "Thanks a Zillion Zig" roast scheduled for August at the National Speakers Association conference.

The Writing Scene...

When Helen is not photographing, she is writing. Two of Helen's books were released during 1998. *Black and White Portraiture* (Amherst Media) came out in April and *Family Portraiture* (Amherst Media) was released at the beginning of December. You can find both at your local camera store or at *Borders Books*. The books have been getting compliments left and right, including an excellent review in *Library Journal*. Thanks for making Helen look good!!!

Several more books are currently in the works. Helen has already written two books this winter, and she has contracts signed for two more! *Black and White Portraits of Children* (Amherst Media) is due out January or February 2000. She also wrote her second book for Eastman Kodak, *Ideas That Work Volume IV*. She expects to have her third book manuscript completed before the end of June, a business book geared toward photography studio owners. Her fourth book project for '99, *Studios of Stars--Successful Photographers and Where They Work* (Amherst Media), includes interviews with successful studios from across the U.S. and around the world. It actually won't be released until some time in 2001. This brings the tally to fourteen books since her first one was published in 1990.

Caring For Your Portraits...

We need your help to ensure your portraits last a lifetime. Three elements are very bad for portraiture. *Direct sunlight. Excessive moisture. Fumes.* Most people realize that direct sunlight causes anything to fade, but few realize that excessive moisture is also bad. The moisture issue is why you should never put a photograph in an easel back frame where the glass rests right on top of the picture. Use archival quality matting to give a bit of air between the glass and the photograph.

Fumes cause the most problems because they are such unexpected trouble-makers. Photographs cannot hold up to excessive chemical fumes. For example, if you have your wood floors stripped or all the walls in your home painted or new wall-to-wall carpeting installed, wrap and remove your portraits until the odors subside. Framing your little extras can also cause problems for the unsuspecting because deadly fumes are in cheap framing products. Few people realize that *foam core*, a common product used by professional framers, contains formaldehyde, which will cause a black and white portrait to discolor. To protect your portraits, follow the example of Boursier Photography and use only archival products.

Our Favorite New Product...

Traveling to photography conferences across the country and around the world helps to keep the Boursiers current on new products and new styles of photography. Our two-week trip to Italy last May is responsible for our newest item. The Watercolor Portrait. It is a unique blend of old time portraiture and modern technology. These one-of-a-kind pieces begin with a camera you can only find in antique shops.

After the photographs are created on location, the emulsion of the image is manipulated at the studio and then scanned into the computer for additional design work. The completed portrait is presented on watercolor paper and matted and framed. Watercolor Portraits are available in either color or black and white. Because each requires a completely different camera, film and process, you must commission the Watercolor Portrait prior to your session.

Time For Tea...

You have an open invitation to join Helen for tea. Just give her a call when you are going to be in the area! She would love to show you what she has been doing and get caught up on what you have been up to too. Call her at 800- 903-3950. She always has time for tea!

BOURSIER 1-800-903-3950
74 Carol Ave. ❖ E. Falmouth, MA 02536-5943

Here's the information you requested – Thank You!

Use a consistent logo, typestyle, color ink and choice of paper for all your printed materials. Top: Envelope for mailing the planning booklet. Bottom: Letterhead.

Opposite page: Our newsletter.

BOURSIER Helen T. Boursier (M.Photog., Cr., A-ASP)
74 Carol Ave. ❖ E. Falmouth, MA 02536-5943

Portrait Inquires: **1-800-903-3950** ● 508/540-3950 ❖ *Fax:* 508/540-6243 ❖ *E-Mail:* boursier@capecod.net

Keep it Simple

A newsletter is a great way to keep connected to your clients. We send out two a year — we keep the newsletter easy to produce, easy to mail (using computerized labels of our mailing list) and easy to read. If it's too much trouble to produce — and to read — it will end up never being mailed and/or never being opened and read!

The spring issue is the most detailed, and it includes a wrap-up of our winter speaking trips and notes any awards or recognition we received at the Professional Photographers Association of Massachusetts annual spring convention. We also include a "back to business" special for current clients and introduce the new product we are introducing each year. The personal information varies from year to year, depending upon what is happening in our lives. For example, the year we celebrated our twentieth wedding anniversary, we included an article about how we met, where we got married, and how we happened to relocate from the West to Cape Cod. The article included a romantic portrait of the two of us "honeymooning" in Italy in honor of our twentieth.

The winter newsletter looks more like the letters you get from family and friends during the holidays. We print it on seasonal winter stationery and mail it at the beginning of January. (We used to get it out in December, but "Happy New Year" works just as well and is much less pressure on us!) We thank clients for their business, remind them that we are now "closed for the season," estimate when we will reopen (usually mid-April) and give them an overview of our winter travels and writing projects. It really just updates clients on what we are up to on a personal level.

We maintain continuity throughout all these pieces. Other than the snow scene letter in January, they are all printed on light grey paper with black ink and lavender/purple accents. The logo and type style are the same. The pieces all feature our hand colored black and white portraits. Your portraits should have an easily recognizable style, and your printed materials should too!

CHAPTER FOUR

Getting the Phone To Ring — Marketing Your Art

I frequently receive phone calls from panicky photographers who want to know how to jump start their businesses — fast! The question is always, "What promotion can I do to generate some quick sales?"

Panic no more. Business is as convenient as the clients in your own back yard, and getting the telephone to ring is the easiest aspect of operating a portrait studio. There is only one simple rule to follow — you must give people a reason to call. Any reason!

"...you must give people a reason to call. Any reason!"

Our Cape Cod portrait studio joins many other local businesses and closes for "the season" when the tourist trade winds down. Seasonal shops close mid-October, but we stay open until mid-December to meet our Christmas deadlines. Reopening mid-April to early May after a five-month standstill is a little scary. We use a series of promotions to jump start the business and fill the calendar with portrait appointments fast.

When we mail our "re-opening" newsletter on March 31st to the 1200 clients on our active client mailing list, twenty business days later we generally have sixty to eighty family and children's portrait sessions booked. The phone does not stop ringing all summer because we continually give clients a new reason to call.

Our back-to-business newsletter generally includes one primary promotion for a "pre-season" special for family portrait session scheduled during May or June. We offer a very small

Certificates for Charity

Not only does donating certificates for fundraisers support your community, it also allows you to increase your client base. Interpersonal communication, or talk between two friends, is perhaps the most powerful buying influence on earth. And charitable donations will surely increase positive "word of mouth" about your studio. It's also another reason why customer service is very important — happy clients are your community "sales" force.

session fee, as much as eighty percent less than normal, plus a flat $100 off any hand colored wall portrait for orders placed before July 1st. Our prime time photography months are July and August, and we cannot accommodate everyone during that 60-day period. The early booking and early ordering bonuses help to relieve the pressure on our summer calendar. It also relieves pressure from our fall production by encouraging those early session clients to also make their portrait selections ahead of the "last chance to order for Christmas" crowd.

Mid-April through the end of June is also when we honor all of the many certificates we donate throughout the year to a variety of non-profit organizations. When any charity asks us to donate to a fundraiser auction, we donate certificates valid for a free weekend session at one of three Falmouth locations (our "basic session" discussed in chapter two) and one 8x10 black and white portrait or $100 of any hand colored portrait. If it is a silent auction, we donate two certificates. For live auctions, we donate four. Most fundraisers are held during the first four months of the year, and all our donated certificates are valid through June 30th.

These certificates are a great way to support the community of our clients, and we actively encourage clients to call and ask us to make these donations. In fact, we often include a reminder in our newsletter. For example, our current newsletter carries the following article:

Charitable donations...

We support our community by supporting your favorite charities. All you have to do is ask, and Boursier Photography will happily donate a family portrait session and one black and white 8x10. Your charity will make the most money if you include this certificate in the live auction section of the fundraiser and bring your own family or children's portrait in as an example of our work. Call Boursier Photography today.

We ask each organization to send us the names and addresses of those who actually win the certificates. Then we follow up with reminder cards at the beginning of June to let them know the certificates expire at the end of the month. If anyone needs an extension on the deadline, we will offer a "rain

Old Colony

Montessori

School Auction

Donation

Certificate

Here is an example of the donation certificates we use. Left: Front of donation card. Below: Inside of donation certificate.

Boursier *Helen T Boursier*
PHOTOGRAPHY

• 184 Jones Rd • Falmouth, MA 02540-2959 •

PORTRAIT INQUIRES: 508/540-3950 • 1-800-903-3950
BUSINESS FAX: 508/540-6243
E-MAIL ADDRESS: boursier@capecod.net
~Available by appointment~

*Good for a weekday family
or children portrait session,
at Woodneck Beach or
Quissett Harbor Beach
on Cape Cod in Falmouth,
and one-8x10 classic black
& white portrait
—or—
a Prime time portrait
session at any location with
all photographs additional.*

— ❖ —

Valid through July 30, 1998

check" valid through the following June (with "blackout dates" in July and August). Then, I send a second reminder the following May to let them know the date must be reserved by June 1st. The most common groups we support are public and private schools, pre-schools and churches. We have also been the primary fund raiser for a swing set at a local elementary school and for a memorial college scholarship honoring teenagers who were killed in a car accident. The certificates are a win for everyone. They enable us to support the community, support our clients and to generate pre-season sessions for us. Meanwhile, the new clients donate to the charity they believe in and save money with us at the same time.

The third promotion we offer during our first months back is a "practice session" for me. There is always some special project that I am working on, and I invite special clients in for a practice session during May and June. I send hand written notes to thirty or forty clients with the invitation to let me do a practice session, and I explain, "Of course, the session and an 8x10 (or $200 off anything else) are on me." Because I genuinely need to do the practice sessions, I make it as worthwhile as possible for my clients. It is a win for the client and a win for me.

The project varies from one year to the next, but there is always a project! Some years I spend a week at an intensive photographic workshop, and I need to put the new ideas to use with practice sessions before I apply the techniques to real jobs. When I was on the home stretch to earn my Master of Photography degree from the Professional Photographers of America, I invited clients who would let me photograph merit print sessions for ultra creative images to enter in print competition. The year I studied in Italy for two weeks, I rounded up a few clients to practice all those new ideas.

Most recently, I made the decision to switch from my Mamiya RB67 camera to a Hasselblad 503 square format system. It felt like switching from Windows (or PC) computer system to the Macintosh computer system or vice versa. Bottom line, I didn't look like I knew what I was doing during the simple act of switching lenses or changing film! To inspire confidence in my competence with new clients, I practiced using the new system on already established clients.

The response is always wonderful. Usually around fifty percent agree to do the session during the designated time

Practice Sessions

Sometimes, photographers can fall into a creative rut — doing the same type of shots over and over and over again. Practice sessions are a great way to keep close to your most loyal clients and for you to try something photographically new — keeping those creative juices flowing.

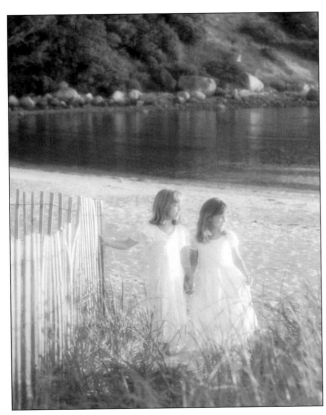

Left: I do a practice session promotion by invitation to preferred clients. This image was taken when I was working on earning my final merit points for my Master of Photography degree from the Professional Photographers of America.

Below: The mother of this ballet student called to take advantage of a pre-season promotion.

frame. They are always open to whatever suggestions I offer, including clothing, location and timing. It is very endearing to have the unconditional support of these clients. Because I am so pumped up with my new ideas, and because they are so supportive, I typically create some of my best work of the season during these sessions. These promotions are the backbone of my marketing. I never use newspaper ads. I have only a single line listed in the Yellow Pages. I never advertise on the radio. You won't see us on television.

During the remainder of the year, I fill my calendar with non-promotional sessions that I attract by displaying our portraits in local artist fairs. I have participated in several through the years, but my all-time favorite is the Falmouth Arts and Crafts Festival held on Main Street the Wednesday following the Fourth of July.

We pay about $250 to rent a ten-by-ten-foot piece of black-top on Main Street in the heart of Falmouth. The day-long event is festive and fun. The organizers also include entertainment like strolling musicians, jugglers and clowns. Non-profit groups cook up all types of ethnic food. An estimated 80,000 people stroll the street looking at what the vendors have to offer. We hand out hundreds of sample packages of our Cape Cod Collection notecards (see page 44).

By the end of the day, I am always amazed at the number of people I know and the number of new prospects who have never seen our work and can't wait to call and schedule a session. My calendar is typically full for the season within about two weeks after this festival!

To turn the art fairs from passive to active promotions, I create some specific promotion that is tied to the one day of the fair or festival. Sometimes, I conduct a drawing for one free family portrait session and an 11x14 black & white portrait. Then, I draw an additional twenty names for second place, a free weekday family portrait session and one 8x10 black and white portrait.

At church fairs, I typically offer a free weekday session and a free 8x10 black and white portrait with a $30 donation payable directly to the church fundraiser. I always tie a specific offer with a deadline to take action. Otherwise, folks just stroll by, pick up my sample postcards and go into terminal stall about picking up the telephone to book the session.

Renting Space at a Show

Whatever the initial entry fee, organized shows bring the people to your (display) doorstep. You'll have the opportunity to show your photography to more people on any one day of a well-organized show than during the entire rest of the year of waiting for people to walk through your studio door.

"Sometimes, I conduct a drawing for one free family portrait session..."

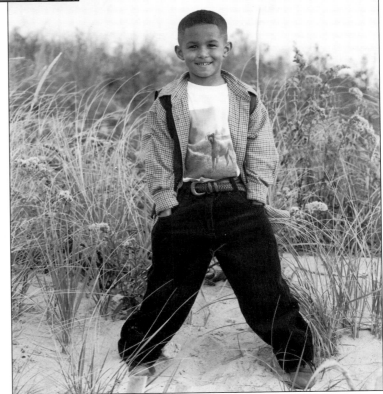

Above: A second place winner at the Falmouth Arts and Crafts Festival, this mother rounded up all eight children plus spouses and grandchildren.

Right: A second place winner from the Cranberry Harvest Festival became a regular client who continues to return for portrait updates every few years.

The "Toys for Tots" promotion is an excellent way to launch black and white portraiture into your community.

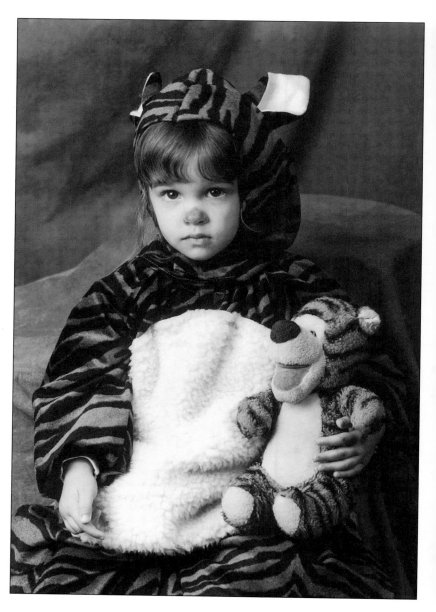

If I ever get a lull in my calendar, I easily fall back on any of the many other promotions I have offered through the years. For example, the promotion that is largely responsible for putting the word out in the community of our black and white portraiture is the "Toys for Tots" open house we ran on Halloween during the late eighties and early nineties.

Between 8:30 a.m. and 4 p.m. on Halloween (or the school day nearest to Halloween when children wore their costumes to school), we did a free 4x5 black and white hand colored photograph in exchange for a new toy to be donated to Toys For Tots through the local chapter of the U.S. Marine Corps Reserves. There was no appointment necessary, and we

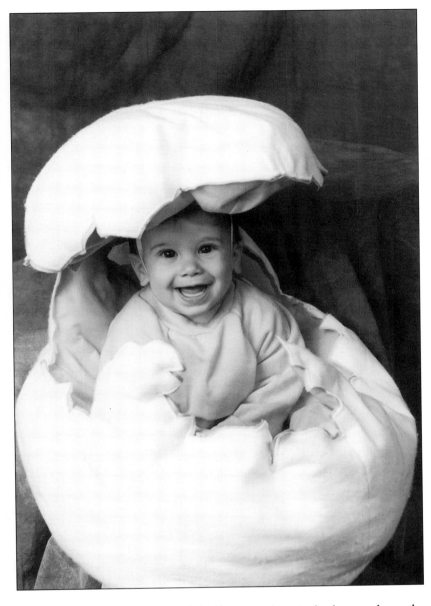

handed out helium filled balloons, donut holes and apple juice. During the early years, we photographed about thirty children, but the final year we photographed nearly three hundred. (We retired the promotion that year!)

An easy spin-off for this promotion is to target it toward family groups. During the month of October (or any designated time), trade a family portrait session for a new toy to be donated to Toys for Tots (or a local charity that distributes toys to needy children in your community).

You can overlap these promotions throughout the year to guarantee your calendar stays full of sessions, or you can just

"We even turn late callers into a promotion!"

run here and there as needed. We even turn late callers into a promotion! Anyone who calls too late in the year for us to accommodate them (it is too cold for the beach or we have reached our quota for the number of sessions we can photograph), we take their names, addresses and phone numbers and follow up with a special back-to-business special in the spring.

Custom notecards

One common denominator throughout all our marketing is the Cape Cod Collection series of custom notecards. Pretty pictures are what got most of us into professional photography. Unfortunately, most of us had to put away our 35mm and view cameras in pursuit of the warm body willing to buy the wedding candid or people portrait.

Our custom notecard series allows us to take pretty pictures and do some awesome marketing. A similar "hometown collection" will work for you too. Our set is divided into a scenic series of ten Cape Cod scenes and a second series of ten illustrative portraits of children on Cape Cod beaches. All twenty are hand colored black and white images. They are printed on heavy stock 5x7 cards, and the printing is matt (as opposed to a glossy surface postcard) for a classy look. (See samples on the following pages.) We use the backs of the cards for low key marketing. The scenic collection was taken by my husband and partner, Michael Boursier. The back of the notecard reads:

> *Michael L. Boursier* is a fine art black and white photographer and master printer. Mike's work is also available as canvas wall decor through Boursier Photography. Each image is individually hand colored, bonded to artist canvas and elegantly framed. For information call...

The children's set features a collection of my work. On the back of these notecards, we have printed:

> *Helen T. Boursier* combines the perfect detail of a photographic image with the artistic interpretation of her artist palette. Her hand colored images have been displayed on three continents and across the U.S., and Helen is available for private commissions through Boursier Photography on Cape Cod. For information call...

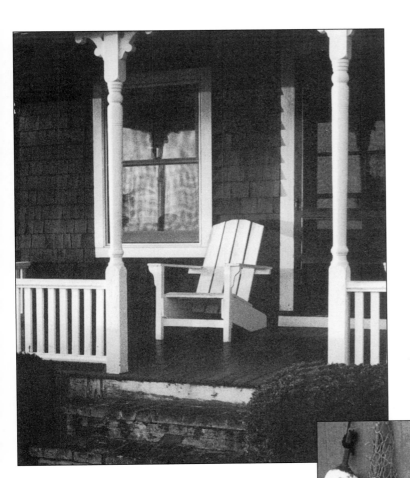

Notecards make excellent promotion pieces. We have made two series of notecards. These are examples from the landscape series done by my husband and partner, Michael Boursier.

Two more examples of Michael Boursier's landscape notecard series.

Examples of my work featured on the children's set of notecards.

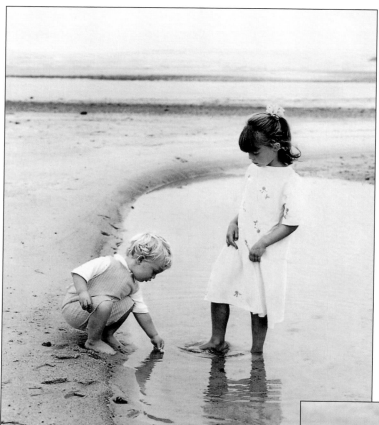

More examples of my work from the children's notecard set.

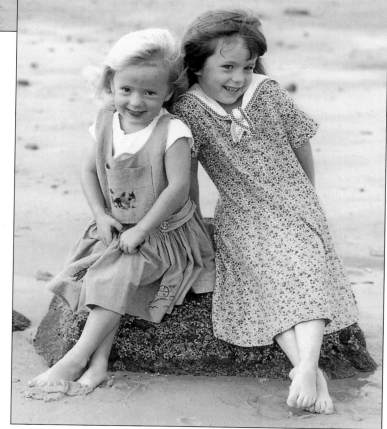

We planned to place the cards in local gift shops, but we ended up using most of them for our own marketing. We use the children's set for direct marketing and the scenic set as thank you gifts for clients at Christmas and for clients who refer us a new client.

The direct marketing includes passing out sets of ten during the Falmouth Arts and Crafts Festival. We also include a set when a client buys a gift certificate for a friend or family member, and a set goes out with every certificate we donate to the fundraiser auctions. The only negative comment we have ever heard is that both sets of cards are too pretty to use! (Many people have said they individually matted and framed the entire series!) We always tell clients to use the cards and we will happily send them more!

Computerize your client list

The best source of on-going and future business is repeat business from your client list. As a Minnesota photographer friend of mine once said, "If they have been to us before, I prefer that they come again!" However, if you don't keep track of your clients — all your clients— you won't have an easily accessible way to reach them. Pretty simple. Pretty obvious. And amazingly, pretty much ignored.

During early January, we load all our client names from the previous year's invoices into the computer and generate a simple mailing list of our preferred clients. It is a ridiculous waste of time to flip through invoices and hand-write labels every time you want to do a direct mailing to your clients. A computer and some software is a good investment that will increase your marketing possibilities while saving you time.

Be a copy-cat

If you see a good marketing concept — copy it! I'm not talking about stealing ideas from other photographers. Why offend a colleague when there are piles of ideas compiled by ad agencies? The ideas are only as far away as your mailbox. Sort your junk mail with a sharp eye for marketing ideas.

Getting your phone to ring is as simple as giving your clients a reason to call. The reason makes them want to call, and the deadline makes them pick up the telephone and do it now!

Computer Software

There are a variety of computer software programs available, from the most basic to the terribly complex. The main consideration when choosing a database software program is the ease in which you can quickly generate mailing labels for all your direct marketing promotions.

Borrowing Ideas

We borrowed a concept from a major credit card with its "free first class upgrade" airline promotion. We issued coupons to our preferred customers for a "free canvas upgrade" during a designated time frame.

CHAPTER FIVE

Packaging Your Product

"Black and white photography lends itself...to a myriad of presentation styles."

What happens after the session...

Multi-colored tissue paper size guides: Size selection is a combination of how large or small you want the faces to be within the portrait and how the outside dimensions balance with the walls and furniture in your room. Unfold the enclosed tissue paper size guides and use them to give you an idea of which outside dimensions will look best in your home. During the slide projection viewing you will see exactly how the subjects will look for each portrait size.

Purple tissue=30" Pink tissue=24" Yellow tissue=20" White tissue=14"

Menu of choices: We have modeled our menu of portrait choices after our favorite cuisine: Mexican! The first four concepts of "combination plates" reflect what our clients most frequently purchase. Each one combines the session with completed portraits with framing of your choice, and each combination saves you money. The a la carte concept five puts control in your lap with individual prices for each item. If you don't see exactly what you are looking for, please ask for a customized menu!

The final selection: Slide proofs will be ready about one week after your photography session, and they are available for viewing by prior appointment at our East Falmouth studio. During the viewing, you will see the people you love come to life on our studio wall. Everyone who wants to be part of the decision process should plan to attend because you will make your final selections at this time. The appointment takes about an hour. You are welcome to bring your children, but little ones can become restless and make it difficult for you to concentrate.

Slide proofs do not leave the studio and are not available for purchase. Also, slides and their negatives are held up to 60 days, or the first viewing (whichever comes first). Please advise Helen prior to your photography session if you need slides available *sooner* or held for viewing *longer*, and she will do her best to accommodate your special needs.

Deposits and Payments: We require a 50% deposit to begin your order, and the balance is due upon completion approximately eight to ten weeks later. (Mass. requires we collect 5% sales tax for all portraits created in this state, even if you live elsewhere.) We do free delivery for all orders pre-paid (or with the balance billed to your Visa or MasterCard) immediately upon completion. All others will be shipped COD via insured UPS, also immediately upon completion.

Unconditional guarantee: We stand behind our work 100 percent. We guarantee you will love your portraits. Period. In addition, every Boursier portrait framed by us comes with an unconditional replacement guarantee. If anything goes wrong with it, ever, we will replace the portrait at no charge. (Portraits framed elsewhere will be replaced at fifty percent of the current price.) We have replaced portraits for some pretty wild reasons including cat claw marks, a professional painter splattering bleach on a portrait, and a mother backing out of the driveway and running over her portrait after stopping en route home to show her friend! All were replaced at no charge.

A corner of our frame collection.

-7-

A page from our planning booklet.

Black and white photography lends itself beautifully to a myriad of presentation styles. The more variety of finished products that you offer, the wider range of clients will find something they want to purchase. If left up to only our preferences, we would offer only large sized portraits mounted on canvas and displayed in elegant frames.

Not everyone likes what we love, so we have learned to listen to our clients through the years, offering new products based upon their interests and their desires. After all, the portraits are going to be displayed in their homes!

Page seven of our portrait planning booklet (see chapter three) explains how we organize what we offer. It includes an explanation of how to use the tissue paper size guides to select size, an overview of portrait product choices, how clients will view the portraits, the deposit we require and our unconditional guarantee.

Pages eight through fourteen give specific prices and sizes for each of the five distinct products we offer. We want our clients to have as much information as possible prior to the viewing session to help them begin to visualize how they will use their own portraits. The more decisions they can make about their likes and dislikes ahead of time, the easier they will be able to make their selections once they do come to the studio. I don't want or expect clients to know exactly what they want before viewing their own images, but I do want them to begin thinking about what they might like. The following is an excerpt from our handbook that explains to the client what happens after the session:

After the session...

Multi-colored tissue paper size guides: Size selection is a combination of how large or how small you want the faces to be within the portrait and how the outside dimensions balance with the walls and the furniture in your room. Unfold the enclosed tissue paper size guides and use them to give you an idea of which outside dimensions will look best in your home. During the slide projection viewing you will see exactly how the subjects will look for each portrait size.

Purple tissue=30"

Pink tissue=24"

Yellow tissue=20"

White tissue=14"

Menu of choices: We have modeled our menu of portrait choices after our favorite cuisine: Mexican! The first four concepts of "combination plates" reflect what our clients most frequently purchase. Each one combines the session with the completed portraits with the framing of your choice, and each combination saves you money. The *à la carte* concept five puts control in your lap with individual prices for each item. If you don't see exactly what you are looking for, please ask for a customized menu!

The final selection: Slide proofs will be ready about one week after your photography session, and they are available for viewing by prior appointment at our East Falmouth studio. During the viewing, you will see the people you love come to life on our studio wall. Everyone who wants to be part of the decision process should plan to attend because you will make your final selections at this time. The appointment takes about an hour. You are welcome to bring your children, but little ones can become restless and make it difficult for you to concentrate.

Tissue paper templates

No matter how detailed your size descriptions are on your price sheet, the client will be happier with something tangible to take home that shows the various portrait sizes. This way, the client can get a much better sense of what the overall size will look like in his or her own home.

"Everyone who wants to be part of the decision process should plan to attend..."

51

Slide proofs do not leave the studio and are not available for purchase. Also, slide proofs and their negatives are held up to 60 days or the first viewing (whichever comes first). Please advise Helen prior to your photography session if you need slides available sooner or held for viewing longer, and she will do her best to accommodate your special needs.

Deposits and payments: We require a fifty percent deposit to begin your order, and the balance is due upon completion approximately eight to ten weeks later. (Massachusetts requires we collect five percent sales tax for all portraits created in this state, even if you live elsewhere.) We do free delivery for all orders pre-paid (or with the balance billed to your Visa or MasterCard) immediately upon completion. All others will be shipped COD via insured UPS, also immediately upon completion.

Unconditional guarantee: We stand behind our work one hundred percent. We guarantee you will love your portraits. Period. In addition, every Boursier portrait framed by us comes with an unconditional replacement guarantee. If anything goes wrong with it, ever, we will replace the portrait at no charge. (Portraits framed elsewhere will be replaced at fifty percent of the current price.) We have replaced portraits for some pretty wild reasons including cat claw marks, a professional painter splattering bleach on a portrait, and a mother backing out of the driveway and running over her portrait after stopping en route to show her friend. All were replaced at no charge!

The portrait concepts

The five portrait concepts divide our offerings into distinctly different products.

Concept one, framed canvas wall portrait collection, includes two or three hand colored black and white or classic black and white canvas wall portraits. Each one is framed to the specifications of the client, and traditional matting with acrylic is available for a small additional fee.

Replacement Guarantee

Long before color labs and film suppliers started their marketing programs to promote the "lifetime guarantee" concept, we offered a 100% replacement guarantee. The guarantee is simple: If your portrait is damaged for whatever reason, simply return the portrait for a free replacement.

Left: Classic wall grouping shown on the left and contemporary triple shown on the right.

Below: Traditional family double shown matted and framed.

Above: The inside foyer of our studio shows a basic wall grouping in the left corner and a Matte Collection with three 11x14 portraits on the right wall.

Right: The Watercolor Collection series is available separately matted and framed, or as one piece with multiple watercolors matted and framed like the Matte Collection series (see photo above).

"...combinations of wall portrait sizes that our clients have consistently selected..."

The seven choices are combinations of wall portrait sizes that our clients have consistently selected through the years. Some groupings appeal to large family groups, and others work best for children or an individual family of four or five people.

For example, the small trio grouping of three 11x14 portraits and the medium trio grouping of three 16x20 portraits are popular for individual portraits of children. Groupings combining a family portrait with a children's portrait with an accent sized portrait of the parents (or a second one of the children or family) include the basic wall grouping with one 16x20, one 11x14 and one 8x10 or the classic grouping of one 20x24, one 16x20 and one 11x14; or the traditional family trio of one 24x30, one 20x24 and one 11x14.

For clients who want a large portrait of the family with a slightly smaller one of the children select the traditional family double of one 24x30 and one 20x24. The contemporary triple has one 20x24 and two 16x20 portraits.

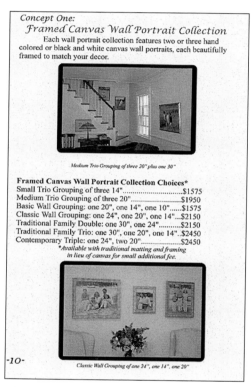

Concept One:
Framed Canvas Wall Portrait Collection
Each wall portrait collection features two or three hand colored or black and white canvas wall portraits, each beautifully framed to match your decor.

Medium Trio Grouping of three 20" plus one 30"

Framed Canvas Wall Portrait Collection Choices*
Small Trio Grouping of three 14"..............................$1575
Medium Trio Grouping of three 20"........................$1950
Basic Wall Grouping: one 20", one 14", one 10"......$1575
Classic Wall Grouping: one 24", one 20", one 14"...$2150
Traditional Family Double: one 30", 24"...............$2150
Traditional Family Trio: one 30", one 20", one 14"...$2450
Contemporary Triple: one 24", two 20".................$2450
**Available with traditional matting and framing
in lieu of canvas for small additional fee.*

-10-

Classic Wall Grouping of one 24", one 14", one 20"

A page from our planning booklet.

Concept two presents smaller sized portraits matted and framed in what we call Matte Collections. The price includes the session, the designated number of black and white or hand colored black and white portraits, matting, frame of the client's choice and acrylic. The portraits may be matted for display horizontally or vertically, and clients may mix and match sizes within the piece. Matte collections are available with one to five portraits. Since our work is labor intensive with the hand coloring and print enhancement included with every portrait, we do not price the portraits by the square inch. Consequently there is one price for 8x10, 8x8 and 5x7 and another price for 11x14, 11x11 and 10x10.

Concept three presents a unique product that blends the old with the new. The Watercolor Collection combines old-time portraiture of the Polaroid SX-70 instant film with modern computer technology for a one-of-a-kind look (details in chapter fourteen). The 8" square portraits are offered as color or classic black and white, and they are individually matted to fit a 14" square frame.

Concept four presents four to seven small canvas portraits in what we call a Miniature Masterpiece Canvas Collection. Wall portrait groupings look best when displayed on a wall you will view from across the room, but the concept four series looks best when displayed on a wall you view up close. Where the wall portraits give impact through the expressions of the sub-

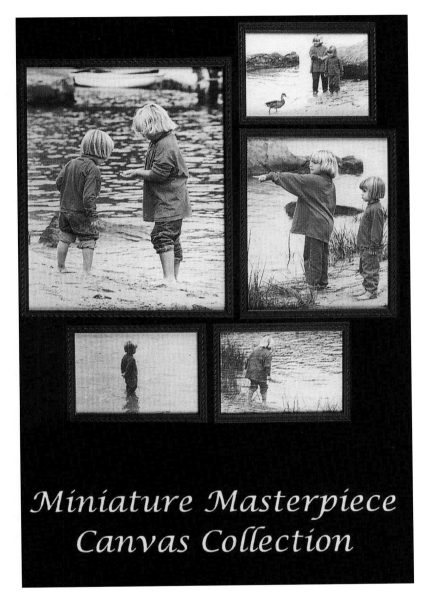

Miniature Masterpiece Canvas Collection

The Miniature Masterpiece Canvas Collection is available in several variations. The canvas miniatures are individually framed, then connected so they hang as one piece.

jects, the canvas miniatures give more of a story-telling feeling. The combinations include one 8x10 and three 5x7s; two 8x10s and three 5x7s; one 11x14 with one 8x10 and three 5x7s; or two 11x14s with three 8x10s and two 5x7s. Clients may choose any frame style that is ⅝" or ¾" wide. They may choose to have the miniature portraits connected so they hang as one piece, or they may opt to have each one separate. I prefer when clients choose to have the portraits connected because the portraits are too small to display individually.

The à la carte concept five is ideal for clients who want one portrait. This series also offers add-on gift portraits. (Again, 8x10 and smaller are the same price.)

We have divided our portrait offerings by concept because it makes it easier for clients to choose their favorite look. It is not uncommon for a client to say they like the idea of either the matte collection or the miniature masterpiece collection. I show all the samples for both collections, and the client easily decides which she prefers. Another client might choose one wall portrait from the à la carte series as well as a miniature masterpiece or matte collection to display in another room of the home. Of course, virtually everyone includes several add-on gift portraits.

Framing

We carry about three hundred corner samples in a wide range of frame styles. When we first began our business, I did not want to bother with framing. Now, I see it as a service to my clients that I could not and would not do without. It all began when I would visit with a client one, two or even three years after they had purchased a portrait only to find out that they never got around to getting it framed. What a waste! Then, I would see some of our portraits hanging in clients homes, and they were displayed in poor quality frames that cheapened the beautiful portraits. Then, we started replacing portraits that framers had damaged because they did not use archival materials. We finally said, "That's it! We need to finish what we start, and offer full service framing."

Looking for new and different frames that would appeal to our clients has become a new winter hobby. Finding a wonderful new frame is like falling in love with a great piece of jewelry. You know with just the right portrait and just the right home decor, the frame will look stunning. I go through my frame corners regularly, adding new looks and taking away old. I also update my studio samples each year to reflect the current trends and newest looks.

To make frame selection easy, the prices for all the popular sizes are noted on the back of each and every frame. The wall is hung with thick carpeting that has a loop so the velcro on the backs of the sample frame corners stick to the carpeted wall. All the client has to do is remove the corner from the frame wall and look at the price. It is tedious to update prices on all those frames, but it makes it so much easier for clients to select their frames.

With concepts one through four, clients may choose literally any frame. Concepts one through four essentially include the

Stock Corners, Not Frames

In the past, we stocked batches of frames, but never seemed to have quite the right sizes or finishes the clients wanted. The ones we did have got banged around to the point we had to offer them at reduced prices. Now we carry about 300 corner samples from several suppliers who ship quickly.

wholesale price of the frame, so a few dollars higher or lower is incidental. I would much rather the client choose what they like best. Period. In addition to making the frame selection as easy as possible, we also throw in the unconditional replacement guarantee mentioned earlier.

When you are figuring out your own portrait offerings, remember that big is not necessarily better. Although our own home is filled with 24x30 canvas wall portraits (my favorite size), I realize that other people need other choices. I am always keeping my eyes and ears open for new ways to package our product and keep our clients happy... and coming back for more.

"I am always keeping my eyes and ears open for new ways to package our products..."

"...you are able to control your business instead of your business controlling you."

CHAPTER SIX

Basic Business Work Smart Rules

The most important guideline for setting up guidelines is to set up guidelines! Then, once you have established guidelines, remember that you established those guidelines because they are in the best interest of both you and your clients.

By sticking to your guns with the various policies you establish, you are able to control your business instead of your business controlling you.

Don't answer the telephone just because it is ringing...

You can waste a lot of time if you stop what you are doing every single time the telephone rings. The caller's questions can easily catch you unaware, putting you on the defensive and causing you to rush through your answers. It is also very rude to interrupt an appointment with your client to answer the telephone.

When I am with a client, my associate (or the answering machine) answers the telephone. Mike will only "beep me" with a call when it is actually for my client. When clients hear my telephone, they always ask if I need to answer the phone. I reinforce their importance to me by responding, "Thank you, but I will just catch that call later." The priority should always be on the person in front of you, and not a ringing telephone.

If you do not have a full-time receptionist who can handle your telephone inquiries, then your best bet is to have

scheduled times to return calls, ideally first thing in the morning when people are usually at a predictable location, either home or work. I update my answering machine daily to advise callers when I will be by the telephone to accept calls and when I will be returning the phone calls they are making now.

This procedure is not "call screening," but work focusing! This very basic time management skill enables you to focus on the most important task at hand. When you are meeting with clients, you are meeting with clients. When you are completing a hand colored portrait, you are completing a hand colored portrait. When you are scheduling appointments and answering questions, you are talking on the telephone.

The clients in front of you are the most important use of your time. Do not let anyone or anything distract you from working with them. Do not allow the telephone to interrupt you while you are working with clients in the studio, and do not allow a passer by to distract you while you are on location.

Don't answer the "do-drop-ins" either...

There is nothing worse than having to stop everything you are doing because someone bops in unexpectedly to look at your photography samples, pick up a completed order or, worse yet, look at the originals from a recently photographed session. I sometimes wonder what folks are thinking when they drop in without an appointment. Surely they must realize that we are not sitting by the front door holding our breaths and hoping someone will come to the studio at that exact moment. Surely they must know that we are, in fact, either already working with a client or engaged in some specific task. There is no professional office anywhere that you can just drop by for a quickie appointment without so much as a single moment's notice!

The best way to circumvent this problem is to cut it off before it ever becomes a problem. Either hire a full-time receptionist whose sole job is to answer the telephone and visit with clients who show up without an appointment, or commission a sign that says, "Available By Appointment."

Next, begin the education process. It is actually very simple. When a client does drop by, do not drop what you are doing and serve them instantly. When you make yourself available to them at the snap of a finger, they will drop in unannounced again and again and again. Instead, I express genuine surprise that they showed up. I might say, "I'm sorry, but I don't have you on my calendar for today. Did I forget to write down your appointment?" Then I get my calendar and make an appointment for my nearest opening. If I am finishing up with a client, I will offer to let them wait in the adjacent sitting room. If it will be more than a few minutes, I ask if they have an errand or two they can run and then stop by at a designated time.

I continually advise clients that I am available by appointment. I don't want to make it such a production that I am not easily accessible, but I explain that if they just show up and try to "catch me," I will either be with another client or photographing on location. I turn it in to a benefit to them by saying, "To make sure you don't waste your time, just give me a quick call when you know you are going to head in this direction. I would hate to just miss you by a few minutes. It might be that I could meet with you before your other errand, or after. You won't have to waste a trip over, and I can have everything out and ready for you when you arrive."

"...commission a sign that says, 'Available by Appointment.'"

Being available by appointment guarantees I am able to give clients my undivided, and well-prepared, attention every single time.

Consolidate your price lists to one...

I have never understood why most portrait and wedding photographers have a different price list for every different type of photography they offer. When you have a different price list for weddings, seniors, families, children, pets, commercial and boudoir portraiture, you make your business too tedious. Not only do you waste a lot of paper from the assortment of price lists, but you also waste a lot of time explaining all those differences to every single client. Why should a wedding candid cost less than a wedding portrait? Why should a high school senior 8x10 cost less than a family portrait 8x10? Why do children's portraits cost less than families? Why does boudoir portraiture cost so much more?

> ### One Price List
>
> When you have a different price list for every type of photography you offer, you waste a lot of time explaining to your clients why you charge more or less for one service over another. The solution: stick to one price list.

Photographers typically offer a separate price list for high school seniors, but that makes it confusing when families of those seniors then schedule a family portrait session. The ultimate question is, "Why are the prices different?"

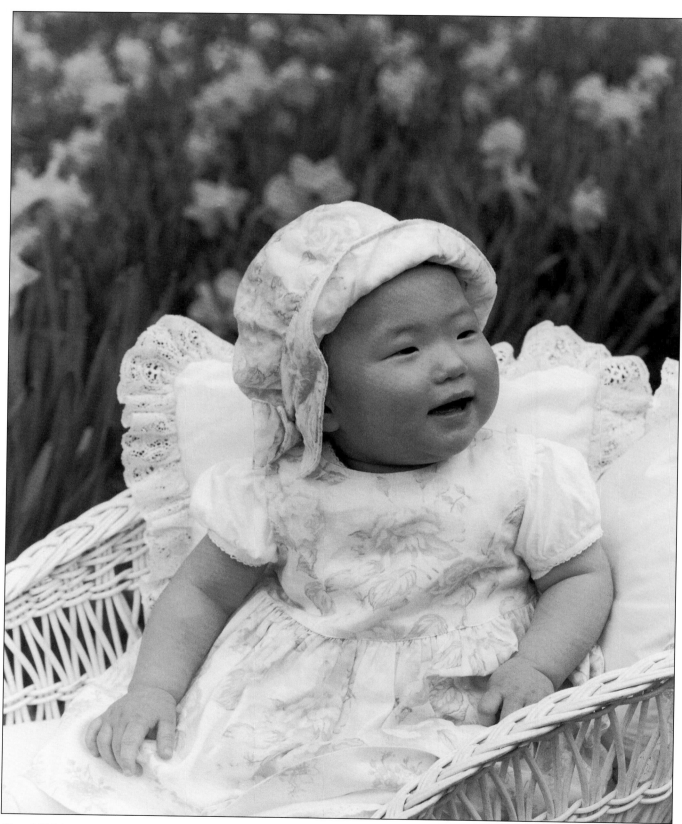

Establishing one fair price for all your subjects, from babies to toddlers to teenagers to families, makes it easier for the clients and easier for the photographer.

The best answer to all these questions is to choose one price that is fair for all portraiture. You will make it easier on yourself and fair for all your clients.

Use a printed price list...

It has been the trend in portraiture to not use printed price lists. Instead, photographers use one master price list that they keep in a leather folio that never leaves the studio. Clients may write down prices for the various portraits they are considering purchasing. The main idea of this method is to place the emphasis on the portraits and to take it off of the prices for those portraits. Car dealers follow a similar theory with their fancy brochures which do not include a single printed price.

The "wine list" pricing procedure has several disadvantages. First it makes you look like you are making up new prices up with each client. It also looks like you are embarrassed or uncomfortable with your prices. Finally, it does not give clients adequate information prior to selecting their portraits.

The customer planning packet that I mail to every client prior to scheduling the photography session includes pictures of the various products we offer plus detailed prices for all the variations of all of the products. The brochure sends the message that we are proud of what we offer, and it enables clients to begin planning their budget to suit their product preferences. It makes things easier for clients because they can think about their choices in advance, and it makes it easier for me because I know they know exactly what we offer and how much we charge for each item.

Value, price, value...

The only way to discuss prices with your clients is to remember the simple phrase, "value, price, value." First you give a benefit for a particular product or size, then the price, then another benefit. For example, when I explain sizes and prices for wall portraits, I might say something like, "The 40" portrait of the family group on display over the sofa is the largest size we offer. It is X dollars and it looks the best when displayed over a sofa, above a mantle where there is a cathedral ceiling or in a front entryway. The 30" portrait of the family of four hanging on the left wall is X dollars and is ideal for smaller family groups. It looks good above a fireplace when the ceilings are eight or ten feet. It also looks good above a

A Planning Folder
A planning folder for the client is an organized way to present all the information about doing business with your studio. It should include your printed price list, a size guide sheet and templates, clothing and hair "rules," details on the various finishes, and a little bit about yourself and your background.

Know Your Prices

There's nothing worse than having a sales person stammer around, unsure of prices, warranty or service. If you don't have enough confidence to know the prices of what you're selling, why should the client have faith in you to part with his or her money? Since you've consolidated down to one price list, memorize it. You should be able to confidently and competently walk around your sales room, point to a sample, and give the size, finish, price and benefit to the size.

sofa when you display a 24" vertical portrait beside it of the children (see page 53). The 24" is X dollars and you can see how much it is the perfect size for a portrait of the kids. The 20" works well when it is included as part of a grouping, and it is X dollars. Many of our clients choose the 20" for individual portraits of their children to display as a grouping going up the stairs or down the length of the hallway. The 14" is also meant to be used as part of a grouping. It is X dollars, and you can see from the example on the right wall how it looks great as an accent piece to go with a grouping of larger portraits."

This explanation helps clients to visualize how the various sized portraits are used within their home. By tucking the prices in the middle and by using the same tone of voice throughout the explanation, I quietly send the message that I believe in what I do. Instead of price becoming "The Big Issue," it is a secondary aspect of the whole portrait selection process.

When I am talking to my clients prior to the photography session, and again at the conclusion of the photo shoot, I remind them to use the tissue paper guides (mentioned in chapter five) before they come to the studio to make their portrait selections. This way, they can visualize in their own homes what the various portrait sizes would look like. My clients routinely talk about the color of the portrait size, instead of the actual dimensions of those sizes.

For example, "The purple or the pink size will fit the space where I want to display the portrait." Then we fine tune the actual size once they choose their favorite pose.

Color code your calendar...

Get yourself a set of five or six transparent highlighter pens in an assortment of colors and designate each color for a specific studio-client session. For example, I use pink for a planning session, yellow for a photography session with Helen, blue for a photography session with Mike, green for a sales session, and orange for an appointment to deliver completed portraits.

"Color coding...enables me to quickly see which kinds of appointments I have scheduled..."

Color coding the calendar enables me to quickly see which kinds of appointments I have scheduled at any given time. I prefer to schedule my sales appointments back to back with my photography sessions closely scheduled on another chunk of time. My worst nightmare is a day with a photography

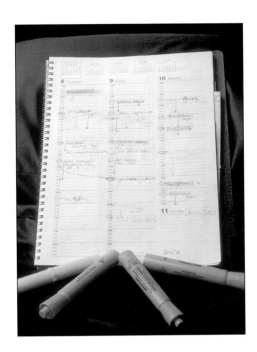

Using an assortment of different colored highlighters makes it easier to keep your appointment calendar organized.

session then a sales session, then another shoot and then back in for a planning session. It makes the day too jumpy and too inefficient.

I use a similar system to identify the promotions behind the photography session. When a client makes the initial inquiry about scheduling a session, I always ask how they happened to call. Then, I take a highlighter pen of the appropriate color and mark over the top of the tracking slip. When they call back to schedule the session, one glance at the color tells me the promotion. I put a small check mark in that color beside the yellow highlighted name on my calendar. It is an easy way to keep track of how many sessions I have for the various promotions, and it serves an easy reminder for a point of conversation while working with the client.

For example, I use lavender for a Boursier Photography preferred client promotion, green for a traditional paid session, blue for a session from a charity auction and orange for a Toys for Tots fall promotion.

Keep track of your clients...

It is important to keep track of your clients from first phone call through completed portraits. We have a pad of 4½x7 forms that we developed for use when we conduct a drawing when participating in an art fair. We also use the forms to keep tracks of clients throughout the year. I keep pads handy

Smart Scheduling

When scheduling appointments, I prefer to lump sales sessions together, as well as shoots and planning sessions. The color-coded calendar helps me to lump like sessions together quickly and efficiently. At a glance, I know what type of session is going on when.

by all the telephones, and I write on them all the pertinent information for each client.

For example, I always ask for the names and ages of the children from the top down. Then, when I arrive at the appointment down the road, I already know the names of the subjects to be photographed. I also jot down any comments the caller makes about what she prefers (i.e. hand colored or classic black and white, individual portraits of the children or just a complete grouping, etc.) and the names of other clients who may have referred her to our studio.

Use the highlighting system to mark your client tracking cards to indicate various promotions. I put a mark across the top of each client card to tell me at a glance whether it is a donation session, a prime time paid session or a Boursier Photography promotional session.

Boursier
PHOTOGRAPHY

NAME:_____

Permanent Mailing
Address:_____

City/State:_____Zip:_____

Home Phone:_____ Work Phone:_____

- -

Alternate Mailing?
Address:_____

City/State:_____Zip:_____

Cape Phone?: (508)_____

- -

If you win the drawing what type portrait would you be interested in? — and — in what setting location?

✓

[] Immediate Family

[] Siblings

[] Extended Family

[] Grandchildren

[] Child (ren)

[] Mother/Child

[] Couple

[] Beach
[] Park
[] Flower Garden
[] Pond Shore
[] Front Yard

When was your last Family Portrait created?_____

Were you pleased?_____Would you like additional information?_____

Do you want to be on our mailing list for future specials?_____

Comments:_____

☺ Drawing valid for complete sets — *siblings, family or extended family*
☹ NOT VALID for an incomplete group *(i.e. one sibling missing)*

I note on the top left corner the date I sent the planning packet. Then, once the client calls back to schedule the photography session, I write the date and time and location on the top right corner. I also use a highlighter pen to indicate the promotion that applies.

A "tickler" system reminds me which stage the clients are in, from initial inquiry through completed order. I use a card file box to sort the slips into various categories prior to the session. For example, there is a divider section for each of the following: send planning packet, paid inquiries, donation inquiries, raincheck for following spring and reschedule (current season). Once the sessions are booked, the slips are filed in order of date on the job board. I overlap the slips so only the names and camera session dates are visible. The slips get moved to an adjacent cork board when it is time to file them under the following categories: film at lab, slides ready for viewing, projection appointment scheduled. This simple system guarantees I keep track of clients without letting any slip through the cracks.

"This simple system guarantees I keep track of clients..."

Sort the mail over the trash can...

The best way to avoid wasting time flipping through junk mail is to sort the mail while you are standing over the trash can. Throw it out immediately if the outside of the envelope reeks junk mail. If you think you might be interested in the enclosed offering, adopt the "touch it once" philosophy. Open the letter right then and there. Make a decision. Take action. Move on. Follow the same tactic for catalogs. It is easy to get suffocated with the piles of catalogs, particularly fourth quarter of the year. It is just as easy to waste time flipping through catalogs. (However, it is very cost effective to immediately throw away all catalogs without looking at them even once – if you don't see it, you can't buy it!)

Cut the negative umbilical cord...

We have adopted a few rules regarding saving negatives to cut down on our need for storage space and to reduce the "I'll just order later" comments from clients. We archive all negatives from which clients have ordered portraits from 8x10 or larger. Also, we save slides and their negatives for sixty days from the date of the portrait session or the first viewing, whichever comes first. If clients need additional time due to unique circumstances, we ask them to notify us prior to the photography session so we can make special arrangements.

Our planning packet states this important information in two locations, and I personally remind clients about this policy at the conclusion of every photography session. Like with everything, I explain the policy from the perspective of being a benefit to the client. For example, "We have an unconditional guarantee that if anything goes wrong with the portrait, ever, we will replace it at no charge. In order to keep track of all of our clients, we save only those negatives which have been ordered from 8x10 or larger."

Be up front about all your policies...

The more up front you are with clients about studio policies, the happier everyone will be. We spell out all of our policies in the portrait planning packet because we want our clients to know exactly what to expect at every phase of the portrait process. If it is a particularly important policy, like the fact that we use slide proofs and project all of the images in the studio, that policy is noted twice in the printed material. Also, like with the negatives issue noted above, I also verbally point out the key policy while talking with clients on the telephone and while wrapping up in the small talk that follows every photography session. The best way to keep clients happy is to show and tell them what to expect in advance.

"You must do for one person the exact same thing you are willing to do for another."

When it comes to establishing policies for your business, remember that consistency is key. You must do for one person the exact same thing you are willing to do for another. Just like the saying of the Three Musketeers, "All for one, and one for all." Define the guidelines you need to run a business that is fair for you, your clients and your family. Then carve those rules in stone.

CHAPTER SEVEN

Simplifying Your Photography Sessions — Indoors and Out

Photographers, by nature, tend to be equipment junkies. They are happiest when they are poking through a camera store and checking out the newest prop or camera system at a jumbo trade show. Over-accumulation is under-productive. Part of our business success stems from reducing the "fiddle-factor" during the photography session.

Basically, keep your equipment simple so you can concentrate more of your time on your clients and less of your time on your gear.

I heartily agree with what Chicago-based commercial photographer Marc Hauser once said, "If I could take pictures without using a camera, I would." Every step of working with my clients during the photography session is part of helping to set the mood for the portrait selection process that follows.

First, I prepare my equipment before the client arrives. I make sure the film is loaded in the camera and that the light meter is set to the appropriate ASA. Using a sharp ball point pen, I write a "cheat sheet" on a tab from the film box. I note the names and ages of the subjects I am photographing.

If I have three jobs back to back, I write the names for all three jobs, stacking them on top of each other on the film clip on the back of the camera. Even when photographing my own family, during the heat of a session, I can easily call out the wrong name. Tucking my cheat sheet in the film clip is an easy way to keep track of client names.

"Basically, keep your equipment simple..."

"...take care of any paperwork prior to arriving at the session."

Then I organize which equipment I need for the session, and I pack my gear accordingly. I photograph with a Hasselblad 503cw with a sidewinder and a remote. I use the 80mm lens for large groups and the 120mm lens for six or fewer subjects. I select the appropriate lens and place the camera on my Bendbo tripod. Then I hang my light meter and my remote around my neck and put a few extra rolls of film in my pocket. That is it. No fuss. No muss. Everything else stays in the trunk of the car.

I also take care of any paperwork prior to arriving at the session. When I photograph, I want to photograph. I do not want to interrupt the creative process with something as mundane as filling out an invoice or collecting a session fee. Therefore, I require that all session fees are paid when the session is actually booked. I let my clients know I will hold their session for ten days from the date they call. They can drop a check in the mail or put the session fee on their Visa or MasterCard. If I haven't received payment within the ten days, I do a follow-up call to ask if they forgot to send the check or did they need to select a new date. "Selecting a new date" is a gracious way to let clients off the hook if they have decided against doing the session.

The ten-day time frame allows clients ample time to mail a check and the follow-up call is a polite way to determine if I can free up the date and schedule it with another client. Best of all, the prepayment policy keeps the paperwork in the office where it belongs.

When clients arrive, I take time to greet each family member by name. For little children, I plop down on my hands and knees, stick out my hand, and say, "Hi. The kids call me "Mrs. B'." I do not mind if teenagers address me by my first name, but I prefer for all other children to address me as Mrs. B. That "Mrs." affords me the status of a teacher, which generally also affords me with a little bit more respect and a little bit more control.

I always photograph the largest group first. If it is family of six, then I do a grouping with all six. If it is a family reunion of 27, I photograph all 27. Speed and variety are two important factors during the first five to ten minutes of the session. My goal is to get as much variety as quickly as possible before anyone in the family experiences meltdown. For every subsequent grouping, I take a few quick exposures and then fiddle with refining the posing or the clothing.

Fluff the Clients

Even if the client spent $80 at the beauty salon right before the session, I will fluff and fix her as if she just finished doing an hour-long work-out at the gym. If I were the client, it would reassure me that the photographer was paying attention to details and it would give me confidence in his or her overall competence.

My camera set-up includes my Hasselblad 503cw with a sidewinder and a remote clicker, a spotmeter and a tripod. I put extra Kodak Tri-X film in my pocket, and I am ready for any location session (left). When you take care of the paperwork in advance and use a simple camera system for photographing, you can concentrate all your attention on your subject (below).

Photographing the largest number of people first gives you the best chance to get great expressions.

Throughout the entire process, I continually reaffirm that the subjects are doing an excellent job. If you take too long fiddling with clothing or with your equipment, clients begin to wonder what is wrong with them that keeps you from clicking the shutter. Get some quick images, complement the clients on their cooperation, and then fuss and fiddle.

When I am working on location, I get "audience participation" by asking clients to help choose the backgrounds for the different groupings. I always honor their request, even if their choice is not as aesthetically pleasing as they think it is going to be. The more I can involve the subjects, the more I give them a sense of ownership of the portraits that we're creating together.

Once I have taken every possible grouping, I go for extra credit – some pose or grouping or background that goes above and beyond what they expect. With a large family

Using timeless backgrounds and having clients bring in their own props keeps the camera room clutter to a minimum.

Whether the session is on location or in the studio, I always walk clients back to the car. While they are getting organized, I do a quick double-check of the photography area to make sure nothing has been left behind (i.e. shoes or a child's favorite toy). The session is not complete until I return to the studio, write up the film order, and organize my camera gear so it will be ready for the next session. Then I sit down and write a quick thank you note to the client. I appreciate all the time and energy they put into planning the clothing and the timing, and I make sure and let them know.

I follow a similar structure for my studio sessions. I use as little equipment as possible, and I keep the camera room clutter free. I only keep the props in the camera room that I will actually use during each particular photography session. All the other props find homes throughout the studio. Also, I use a studio tripod to enable me to move the camera up and down and in and out quickly and easily.

Rotating seasonal props is another important rule to cut back on clutter and keep things simple. I swap seasonal props and do-dads with photographers who do not compete in my market area. Once I have used a prop, like a carousel horse, for a Christmas set, I can't use it again for many years. Instead of terminally storing the horse, I swapped it for three large white paper mache reindeer. Once I had my turn with the reindeer, I rotated them to another photographer on the swap list.

Keeping my props and equipment to a minimum enables me to keep most of my attention on my clients and only a little of my attention on my gear.

Use a Studio Tripod

I have to fiddle with raising and lowering tripod legs while I'm photographing on location because a studio tripod just isn't convenient. However, when working in the studio, a tripod with one center pole that is supported by a small base of wheels is a necessity. With this type of tripod, the camera sits on an arm on the center pole and easily slides from the top of the pole to inches off the ground.

CHAPTER EIGHT

Selecting Your Format for Selling What You Shoot

Many photographers add black and white photography back into their mostly color repertoire because they like the "artsy" feel of the images. That creative element might initiate loading the roll of Tri-X film in the camera, but creativity alone will not get the image on your client's wall.

The only way to bring black and white portraiture completely into the mainstream of your business is to treat it exactly like you treat the color you already sell. You must be able to swap back and forth between color and black and white during your sales presentation. What you do for one, you must also do for the other.

Standardizing how you present the proofs is the most critical factor in bringing your black and white sales up to speed with color. If you use 4x5 or 5x5 format paper proofs for color, you must do the same for black and white.

Likewise, if you present slide proofs for color, but use contact proofs for black and white, you will make the presentation too confusing for clients. Also, when you show color proofs one way and black and white another, you give the first impression to clients that black and white is of lower value than the bigger color images.

What is obvious to photographers is not obvious to clients. You might think, "Well of course the client realizes I am showing small contact prints of the black and white because that is what is easy on my end to produce. Of course the client knows I can make any size enlargements with the black

> "...creativity alone will not get the image on your client's wall."

and white that I can with the color." That is a false assumption. When two mediums, color and black and white, are not presented using the same method (i.e. both paper proofs or both slides), clients stop thinking about the images you are showing and fill their heads with why are they not the same.

Beginning photographers get confused too. For example, when I taught at a week-long school for professional photographers, I used black and white film in my Hasselblad 503cw and color film in my Mamiya RB67. The school provided paper proofs for both mediums, and I displayed those for students to review.

One new photographer asked if the Hasselblad camera could only take black and white and the RB could only take color! The rest of the class groaned, but I smiled. This new photographer was the perfect example of a client, or anyone else who does not know the ins and outs of professional photography. Avoid any confusion by using the same presentation method for both color and black and white.

"Each proofing format has its limitations."

Each proofing format has its limitations. Paper proofs are the traditional way to present images. Photographers like using them because they can easily mail them off to clients, or pack them in a proof folio and send them home with clients who then show them around to family and friends. Paper proofs are easily available from any professional lab. Photographers typically sell the paper proofs as an inexpensive add-on product. Format paper proofs are printed to the "format" of the negative. Square format negatives from a Hasselblad are printed 5x5, the Mamiya RB negatives are printed 4x5 and 35m negatives are printed 3½x5.

Contact proofs are gang printed on one piece of photographic paper. Basically, one roll of film fits on one sheet, making all the "prints" the exact same size as the negative. Newspaper photographers and high school and college students typically use contact sheets because they are inexpensive and readily accessible. (For the untrained eye, they are very small to view and the many images on one 8x10 sheet can be confusing to look at.)

The problems with paper proofs, whether format or contact, are off-shoots of their so-called benefits. The biggest problem is that they do, in fact, leave the studio. In this day of computers, scanners and Photoshop, it is too easy and too tempting for anyone to copy your work by simply scanning it in to

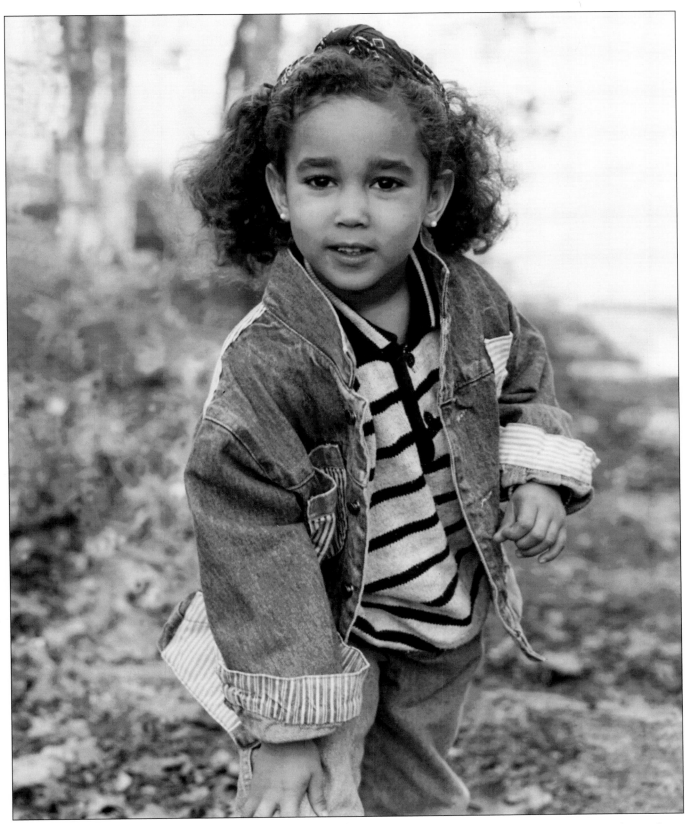

When we initially started offering black & white portraits, I ran a roll of black & white film through on every client whether he or she asked for it or not.

Slide proofs are ideal for showing images to family groups. By projecting the larger image on the wall, it is much easier to determine the best expressions. Also, you can show clients what the pose will look like in any size between 5x7 and 40x60.

their home computer. Although photographers are protected by the copyright laws, many people are unaware (or unconcerned) about these laws. Just like they dupe off their favorite videos and cassette tapes, they have no qualms about copying your portraits. Not only do you suffer from the loss of income, but you also suffer from the poor quality images that then circulate in the community as an example of your work. Your income suffers, but so does your reputation.

When proofs leave the studio, they also leave behind your selection expertise. There are a lot of little decisions that go into every portrait order. Without a professional there to help wade through the myriad of choices, it can become too complicated, too unwieldy and too frustrating. By keeping the images in the studio, the case for all other types of proofing methods, you are able to help clients walk through the decision making process. It is so much easier for them when you are there to assist every step of the way.

"When proofs leave the studio, they also leave behind your selection expertise."

The second big downfall with paper proofs is their size. They are just too small, particularly for viewing family groups. It is possible to use an opaque projector to show the images on a blank wall. You need to have a completely darkened room for the images to show up, and the proofs tend to slide around as you put them on the projector unit. Also, it is a

little awkward to have a paper proof to use for an opaque projection and then not to let them leave the studio. Clients see you with the paper proofs in hand, and they think, "Hey, I should just take them home to decide." Then you end up with the original problem of paper proofs that they do, in fact, leave the studio!

Selecting a proofing system that does not leave the studio is ideal for both photographers and clients. Clients gain the benefit of your assistance, and photographers maintain control of the images they created. In-studio proofing systems include slide proofs, Fotovix or electronic imaging with a digital camera and computer video system.

The Fotovix eliminates the need for paper proofs because the processed negatives are projected onto a high quality television screen. Proponents of this method like the cost saving factor of not paying for paper proofs plus the ease of sliding the plastic sleeved negatives through the Fotovix. As the client deletes a pose, you use a marker pen to put a slash on the sleeve over the negative. This method obviously requires you handle the negatives, which can be risky.

Both computer video projection and slide proof projection enable photographers to literally put on a show and wow clients with the images of their loved ones. For the computer version, the negatives are scanned onto a computer disk (with a digital camera, the images are downloaded directly to the computer from the camera) and projected. With slide proofs, the negatives are copied onto 35mm slide film, processed, and then loaded into slide trays. (Square negatives will result in a square slide, and rectangular format cameras like the Mamiya RB will result in rectangular slides.) I use two slide projections and a dissolve unit which enables me to present the images to music.

> "...the photographer is able to sort the poses into a particular order..."

With either method, the photographer is able to sort the poses into a particular order, give the overall presentation, then go back through the images and help the client choose favorites. Then, using either the computer or the slide projectors, you can show the client literally any size and shape. The computer has the added benefit of displaying multiple poses on the wall at once, even memorizing the grouping to show clients again at a later date.

Some of the objections to using in-studio projection are that you cannot sell the slides after the sales session like you can

The client chose a 30x40 portrait from this pose because she saw it that size on the wall during the slide projection viewing. She liked what she saw!

with paper proofs, there are no proof books circulating to help you with advertising, and you have to get all the key decision makers back to the studio for the viewing. I have been using slide proofs since 1987, and the benefits far outweigh any objections. Most important to me, the quality if the finished portraits leaving my studio is far superior to what would leave if I relied upon paper proofs. Clients have much more control over what they purchase, including size, shape, cropping and how they want the hand coloring rendered. That control enables clients to make better choices, and those better choices result in a superior product.

CHAPTER NINE

Top Ten Rules for Win-Win Sales

Sales success begins by making sure you help your clients get exactly what they want (their "win") while also making sure the sale is fair to you (your "win") for all the time and energy you put into creating the images. The concept of win-win selling means everyone walks away from the sales session happy, and these ten basic rules are excellent stepping stones to win-win sales.

Rule #1: Show what you want to sell. To get the right sales, you must show the right samples. They should reflect the portraiture styles and the actual photography products that you want to sell.

This very basic rule that seems so obvious, is often overlooked. Through my writing and lecturing, I have visited studios in many countries. Regardless of which region of the country or the world that I visit, I always find photographers who do not show what they want to sell! One photographer lamented that none of his families wanted to be photographed outdoors, yet every single sample showed family portraits taken in the studio. Another photographer complained that he just could not convince his clients to purchase black and white portraits over color. Again, the answer was staring him right in the face. All the studio samples were color photographs.

Boursier Photography shows exactly what we want clients to purchase. In the late eighties, when we were gradually phasing out of color and into black and white, we took all of our

"...everyone walks away from the sales session happy..."

Every time we introduce a new produce, like the watercolor collection, we develop a series of samples to show all the variations offered.

color samples off the walls when the color lab deadlines made it impossible to accept any more orders for Christmas delivery. We filled our walls with black and white portraits and continued to accept orders right down to the last minute. We never put color samples back on the walls!

It is also important to display the actual products you want clients to purchase. I have examples in the studio of the variety of portrait options mentioned in chapter five. My walls are not large enough to display every variation of every concept, but I have the extras tucked away in a closet that I can pull out as needed.

Once clients have selected their main favorite poses, I turn off the slide projectors, flip on the lights and show them an overview of the various portrait products. Once they indicate they like the framed wall portrait grouping or the miniature masterpiece canvas collection, then I break out all of the samples within the concept and explain the size and price and pose choices available. This makes it very easy for clients to select exactly what they like.

"Show and tell" got most of us excited during our elementary school years. That same concept will get your clients excited when you let your samples sell.

Show What You Sell

Invest in your samples. You cannot expect sales success unless you show what you want to sell. Rotate your samples once a year, showing new looks and new faces. The samples should also be of the size, shape and finish of what you want to sell. Don't be cheap when it comes to samples.

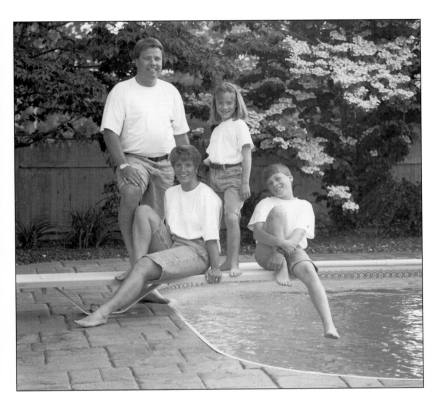

Rule #2: Have a system and work your system. Chapter eight explains the different sales presentation methods and chapter six gives an overview of basic rules that will help you maintain control of your business. Sticking with the ideas you choose to use from both of these chapters is an integral part of your sales success.

When I interviewed a well-known photographic business consultant, Evelyn Lageman, for my book, *Super Sales Strategies*, she said, "Have a system and work your system. Whether you use paper proofs, slide proofs or a digital system, you need to have a system and work it consistently." When I interviewed New Jersey photographer Bruce Lorenz for the same book, he compared the beginning of his sales sessions to a batter getting up to home plate in the major leagues. The batter doesn't give the other team any indication of how he is going to hit. His stance is exactly the same. Then, once the pitch is in motion, he moves his feet to bunt the ball or belt it out to left field. Likewise, Lorenz starts every sales session exactly the same. He only begins to make adjustments once he is well into the sales process.

In the inevitable ups and downs of life, you will have good days and you will have bad days. When you have a system to follow, you are more easily able to convert your bad days to

good. For example, I had to squeeze three sales sessions into a holiday weekend that was already over-booked with photography sessions. All three clients were back in town for the first time since I had photographed their families several months earlier. I scheduled all three appointments back to back at the end of photographing sixty-three children's portrait sessions during our annual Christmas special. I was too tired to think, too tired to improvise, too tired to be creative. Instead, I conducted all three sales sessions following the exact same system I had been using for years. I had a $10,000 sale from one family. Having a system and then working that system was the cornerstone of that sales success.

Rule #3: Know your prices. Nothing gets you more tripped up in the sales room than to stammer around while you look at your price list. We don't offer a complicated product with a

When you offer a variety of portrait styles, your samples should show that variety.

multi-paged, detailed price book. Most of us offer the basic sizes plus a few package combinations. Yet, when I give a lecture on sales and ask how many in the audience could stand up and recite their prices from the top down, only one or two hands come up. The magic stopping point seems to be 16x20. If you do not know how much you charge for your larger sizes and your better finishes, then the client automatically thinks, "Oh, I must have asked about the wrong size."

Not knowing your prices also sends the message that you do not believe in the prices you charge. It is very common for photographers to rattle on and on about all the wonderful things they are going to do relating to the photography. Then, when it comes time to discuss price, their voice drops to a whisper as they shove a price list in front of the client and say, "Oh and this is how much I charge." If the photographer does not believe in the prices for their portraiture, why should the client? And remember, a dog can smell fear. Our clients are ever so much more insightful than the family pet!

Rule #4: Practice makes perfect. You are not going to master Rule #3 (or using a slide projector) by osmosis. You must practice, practice, practice. When the Olympics were held in Los Angeles, Mary Lou Retton needed a perfect score of 10 on the vault exercise to seal the gold medal in the all-around girls gymnastic event. When they asked her later what she was thinking in the moments before she made the run to jump over the vault, she said, "Perfect ten. Just like drill. Perfect ten." Practice does make perfect.

Rule #5: Never assume. Most lessons get learned the hard way, and the hard way is exactly how I learned my lesson on never to assume. I was newly assigned to the Naval Education and Training Center public affairs office in Newport, RI as a Navy journalist seaman recruit when my boss, the civilian editor of the base newspaper, left a roll of processed negatives in a film canister on the top of my desk. When I came back from a late assignment, I picked up the 35mm black plastic Kodak film container. I thought it was out of character that I had not thrown the canister in the trash when I loaded my film for the assignment. I threw it in the waste basket. The janitor tossed the trash. The next morning I had the pleasure of re-shooting the job. Meanwhile, my boss left me a note… "Never ASS/U/ME. It makes an ass out of u and me."

When it comes to the sales session, never assume the client is going to buy or not going to buy. It is a disservice to assume

"You must practice, practice, practice."

you know just what is going on inside your client's head. It is also a disservice to assume you know your client's budget based solely upon looking at him. Stories abound of the car dealer who took one look at a prospective buyer and assumed she was just looking and not a qualified buyer. (I've written letters to dealership owners myself when I was snubbed as a prospect because of the combination of my age, gender and how I was dressed.) Instead, follow sales success Rule #2 and work your system with every client.

Rule #6: Buy what you sell. It is amazing the number of photographers who have a 30x40 canvas portrait on their price list, but the largest size they own in their own homes of their own family is a 16x20 or a 20x24. Basically, if you are too

When I photographed boudoir sessions during the late eighties and early nineties, I made sure and commissioned a 40" portrait of myself (not with this particular pose) so that I would not be asking clients to purchase something that I did not own myself.

cheap to buy it at wholesale, you are never going to sell well at retail. The first time a client balks at a price or says she doesn't have the wall space or comments his home is full of windows, you are silently thinking, "I know what you mean. I have the same problems myself!"

Our home is full of portraits of my own family, and I wouldn't have it any other way. Every room in our home has at least one large canvas portrait, beautifully framed in the molding that matches the decor. I don't scrimp on size. I don't scrimp on finish. I don't scrimp on the matting and framing. I want my clients to select the best, and I do the same for myself.

Rule #7: Help the client decide on the largest part of the sale first and then work your way down to the small stuff. Start with the largest grouping and the largest size. Once a client decides on the pose and size and finish for that, move on to the next largest item.

Some clients will get side-tracked on which poses they want to give for gifts, but it is much better to keep the focus on what they want for themselves. A florist explained it this way, "When a bride comes in to order her wedding flowers, I always tell her to choose what she wants for herself first. Every other woman attending has either had her day, or will have her day. This wedding is for this bride. After she chooses what she wants for herself, I will help her divide the rest of her budget for her attendants and family members."

This great advice also applies to portrait clients. When the mom is deciding on what she wants to purchase, I want her to get what she wants for herself first. This is her family. If everyone else just gets a wallet, so be it. When in comes to choosing portraits, this is one time where moms should be selfish. I encourage them to choose what they want first, and then I help them spread their budget around to get portraits for grandmothers, godmothers and aunts.

Rule #8: Always ask open-ended or alternate of choice questions, and never ask yes or no questions. Were you thinking about a grouping of several portraits, or are you going to concentrate on one main favorite? Do you prefer the hand colored look or classic black and white? Do you want your portraits framed individually, or do you prefer to have several matted and framed as one piece? Do you prefer your frame to be silver or gold or a wood? Do you prefer frames that are narrow or wide? Do you want the molding simple or carved?

Your Own Family Portraits

A good idea is to trade services with another photographer and order the best pose in the best finish in the best size in the best frame. Hang it in a place of honor in your home, and brag about it to your clients. The logic behind this: if you are too cheap to buy your product at wholesale, how can you expect to sell it at retail?

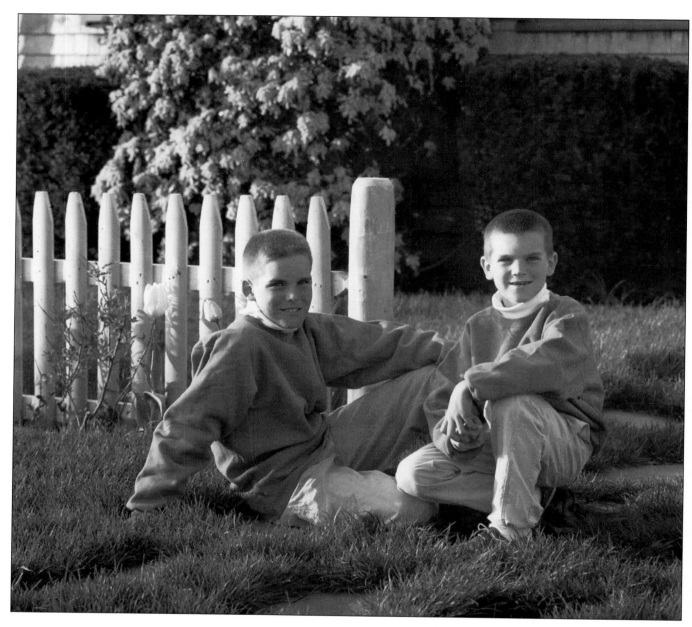

Take time to review every decision before the client leaves the studio. This reinforces all the little decisions that went into the one big decision to buy.

Each question helps clients gradually work their way down through all the little details that go into selecting a finished portrait piece that will be displayed prominently in their home for many years to come.

Rule #9: Review every decision. Once you have followed your system, gradually worked your way through all the poses and all the choices and the client is done making choices, take time to go back and review every single decision. I project each pose selected back on the wall and review every item selected for that particular pose. I repeat the process for all the poses in the order. The more meticulous I am with

reviewing all the choices, the less likely the client will be to call later and make changes. If she hesitates during the review, I know we need to stop and go over the details. The goal is to make sure the client is absolutely certain on every single decision. She will feel better about her purchase, and you will know it is safe to begin processing the order.

Rule #10: Ask for the order. It might seem like a ridiculous rule, but many photographers are afraid to ask for money. You do not have a sale until you ask for the order. After I review the order, I write everything down in detail on an invoice and review it one last time with the client. Then I tally up the total, add sales tax and say, "I just need your approval at the bottom here. You can do whatever you want for a deposit. Some people do half and half, others one third and others pay all of it. Whatever works for you is good, and we take cash, check, Visa and Mastercard."

I want clients to feel in control right down to the details of making a payment. Therefore, I will generally accept whatever reasonable amount they choose to offer. The industry standard is fifty percent, but I have no problem taking as little as twenty percent. If they offer $100 on a $1000 order, I will usually ask if they could do $200 or $250. Since the order will take about eight weeks to complete, I would rather the client have eight weeks to round up a bigger balance than to reduce an order up front because she did not come prepared with a larger deposit.

The success of these ten rules depends upon you personalizing them to suit your business and your clients. The overall key is consistency.

"You do not have a sale until you ask for the order."

When setting up the "rules" for your own business, remember it is important to be consistent.

CHAPTER TEN

More Than Their Money's Worth

"The key to keeping clients is to give them more than their money's worth."

Guaranteeing a long-term successful business means giving clients more than they expect. If all things were equal, it would not matter whether a client bought a 16x20 hand colored black and white portrait from me... or from any of you. The key to keeping clients is to give them more than their money's worth.

That begins with what I call the friend factor. I treat all of my clients like friends. I believe, in another time and place with an unlimited amount of time and resources (mostly time!) I could, and would be close personal friends with virtually all of my clients. That is not a pretentious "sales" attitude. It is a heartfelt belief and a way of life.

The first step to being a friend is being friendly. I chat with clients about all the normal things you would chat with friends about. Family. Vacations. Children's activities. A pretty outfit or a neat piece of jewelry. Photographs. We compare notes on favorite mail order catalogs and we share family recipes. I correspond with all my clients at least once a year when I send my business newsletter. I send Christmas cards and small Christmas gifts. I invite them to stop for tea. I call when I am in their neighborhood photographing to see if they are available for a quick "hello."

I choose to be friendly because I am a friendly person. A four-year-old boy turned to his mother at the end of a portrait session and said, "Mommy, I don't want to go to any other photographers. Let's just come back here." Bingo!

Keep the bathroom spotless, and never use it for storage space.

The Bathroom

You might think this is an odd tidbit to put in a business book, but it belongs here! The client will make a judgement about your business based upon every aspect he or she comes into contact with. Top to bottom, your business needs to be spotless, including the bathroom. Simply put — it shows you care.

Once you start treating all your clients like friends, it is easy to treat them as special guests. That means keeping your office spotless. We give the studio a quick once-over every morning to ensure it is perfectly clean. We vacuum the carpets, sweep the hardwood floors, dust the tables and make sure all the photographs are hanging properly. We also make sure the bathroom is spotless.

A predictably clean bathroom is one of the reasons many people pull off the highway and stop at a McDonald's. We are no exception. Regardless of where our travels take us, the sign with the golden arches is a guarantee that the bathrooms are clean. Break out the scrub brush, get on your hands and knees and polish that floor. Then put up some pretty wall paper, add a vase of delicate silk flowers and hang one or two portraits on the walls.

Presenting the finished product

How well you present and then protect and pack your completed portraits tells clients how you feel about your work. We use all the framing do-dads plus tissue paper, bubbles, bags and boxes.

Framing accessories like picture hangers and rubber pads for the backs of frames are available from United Manufacturers

"For a few pennies more... you can enhance the value of your finished portraits..."

Supplies Inc., 80 Gordon Dr., Syosset, NY 11791. Or call (800)645-7260.

For a few pennies more per client, you can enhance the value of your finished portraits and give clients the feeling that they are getting more than their money's worth. We use black paper on the back of every framed portrait to hide the framing materials and to make the back just as "finished" as the front.

Instead of the cheap sawtooth hanger, we use a flexible black picture hanging wire called Miracle Picture Cord by Acorn Art Systems (available from United Manufacturers). We also include a nail and hanger and the following do's and don'ts tips on where to display black and white portraits:

Caring for your portraits...

Boursier Photography takes great care to create beautiful black and white portraits that will last a lifetime. The life expectancy of the portraits once they leave our studio depends upon you because the environment you display your portraits in is the key factor to their longevity. Direct sunlight, high humidity and chemicals that travel through the air are the three key issues to consider. Any portrait will quickly fade when exposed to direct or bounced sunlight for extended periods of time. Displaying portraits in a room where you need to run a dehumidifier is risky because the room is too damp.

The harsh chemicals in today's world are also harmful to portraiture, including fumes from re-surfacing wood floors, painting interior walls, having carpets professionally cleaned or flea-bombing your home. If you are adding a strong chemical smell to your home, remove and wrap the portraits for a month or so until the odor is completely gone.

Poor quality framing can also cause problems. Some materials have chemicals which are not archival and will damage black and white portraits. For example, foam core contains formaldehyde and will cause portraits to discolor. Also, never allow display tabletop por-

traits to be displayed in frames where the glass touches the photograph. Instead, use matting so the portrait has room to breathe.

When you take good care of your portraits, they will last a lifetime.

Switching to Gatorfoam™ is another value-added benefit for your clients. Double and triple weight mounting board is flimsy in comparison and both inevitably warp. Foamcore is not an archival product as it contains formaldehyde, a chemical that is deadly for black and white portraits. Masonite is just too heavy! When you sell a 24x30 or 40x40 framed portrait, your client needs some serious arm strength to be able to lift and shift the portrait. Gatorfoam gives you the durability without the weight. You can order Gatorfoam from the larger full-service labs, or you can find it at some lumber stores. We purchase ours in cases of 4x8 sheets and have a local carpenter cut it to the sizes we typically sell. (Make sure you buy the white Gatorfoam™ as the kraft version is not archival.)

Tissue paper, bubbles, bags and boxes finish our packaging. We wrap all portraits in tissue paper and place them in fancy black boxes which have been embossed with our logo on the front. NPD Box also offers a variety of colors, but we use black to tie in with our black and white portraiture theme. Contact NPD at (800)969-2697 or write 3000 Quigley Road, Cleveland, Ohio 44113 for exact information.

We slide each wall portrait into a plastic bag, and we have a roll in every size suspended from a pole near the ceiling of our production room. Then we further protect the portrait with bubble wrap. We also stock several sizes of corrugated cardboard boxes for wall portraits that need to be shipped. Our goal is for all the packaging, from beginning to end, to look professional and to do justice to the amount of money the client has invested in the portraiture.

We order bubble wrap from National Bag at (800)247-6000; boxes from Quill Corp. (800)789-1331 and poly bags from United Manufacturers Inc. at (800)645-7260.

Gadgets and gizmos

A few extra gadgets and gizmos enhance your business and add value to your product. Mood music is among the most

Switch to Gatorfoam™

Once you begin mounting your portraits on this excellent product, you'll never use anything else. The 4x8 sheets come in several thicknesses. We prefer and order ³⁄₁₆". Each case includes 15 sheets — we usually order two cases at a time.

"Our goal is for all packaging... to look professional."

important. There is nothing worse than going into a retail store, being the only customer, and having it so quiet that you could hear a pin drop. (My husband once went into a small music store where no music was playing. He promptly walked back out!) Music sets the mood and helps to relax your clients. It also gives a feeling of privacy because clients know you cannot hear every time they turn a page, take a step or blow their nose!

The best way to handle music is to use a CD player where you can stack four to eight compact discs. You should select music that is in keeping with your client base. We press "repeat all" on the player so it recycles continually during the day. I prefer light classical music in the sales room, and I choose CD's that have the same loudness or softness so I do not have to fiddle with the volume during the middle of a session. Among my favorite musicians is Daniel Kobialka. Some of his titles include *Afternoon of a Fawn*, *Timeless Motion* and *Fragrances of a Dream*. You can order his music at your local record store.

Putting your money where your props are is another important way to give your clients more than they expect. You might think plastic pillars look fine once they are photographed, but the client still knows they are plastic. Fake furniture might look real through the viewfinder, but the client still sees it as being fake.

The only way to command quality prices for quality work is to include quality elements every step of the way. Spend the money on the things your clients will come into close contact with, and that means every prop in your camera room. A good rule is to only buy something that you would happily have in your own home.

When you are in a pinch to close a sale and one of the primary decision makers (usually Dad) is not there, you can often still finish the sale by making a Polaroid proof with a Vivitar instant printer available from photo supply stores for about $130. You simply put your slide in a slot on the bottom, press the button, pull out the exposed Polaroid, wait 90 seconds, pull off the tab and you have an instant proof to send home with the client.

I usually make these proofs from the top three to six poses when the wife wants her husband to give the final blessing. We go ahead and make all of the decisions on size and hand

Money for Props

Tacky props will never help your studio get a classy reputation. Invest in some nice (and authentic) props instead of the fake stuff.

coloring and framing. The wife just calls me the next day to tell me the final pose selection. The machine costs about $135 and runs off of four C batteries that will last for years.

Another machine you must have is one that hooks you up to Visa and Mastercard. It is un-American not to accept some form of plastic for payment. Yes, you must pay the bank a percentage for the service, but it is a fee you must accept as a cost of doing business. Debit cards are also a popular form of payment, and you cannot accept debit cards without the electronic hook-up. Contact your local bank for information.

The fax machine is another must-have on your gadgets and gizmos list. It is a great way to communicate with your clients and with your suppliers. We use it to fax out our planning packet for clients who book at the last minute. Clients often fax us details about their order, addresses for extra family members and directions to their home for the portrait session. The fax saves hours of time ordering supplies. Instead of doing things over the telephone during normal office hours, we write our orders down and fax them over at any oddball time.

The key to a successful fax hook-up is to have a dedicated line. Many photographers say they do not have it dedicated because they never receive faxes. Instead, they just use it to send them. The reason they don't receive faxes is because the line is not dedicated. It is very annoying to see a fax number printed on stationery, send a fax over and then have someone pick up the other end of the telephone and say "hello." For $20 to $30 a month, get the machine on a dedicated phone line.

"The key to a successful fax hook-up is to have a dedicated line."

Leave them with something extra

In addition to all the little extras we include throughout our business, we leave every client with a definite tangible extra. The exact extra might vary from client to client, but everyone receives something.

Once clients have placed their order, there is always one more pose or one more photograph or one more set of wallets that you know they would love to order if they had a little bit more money. I order that something extra and give it to them as a "thank you for your order" gift.

Even the smallest order gets something extra. It might be only a couple of wallet photographs, but it tells them I appreciate their business.

Since clients run out of money before they run out of what they want to purchase, I always include at least one portrait of one extra pose as a freebie. The unexpected add-on is my gift for their order!

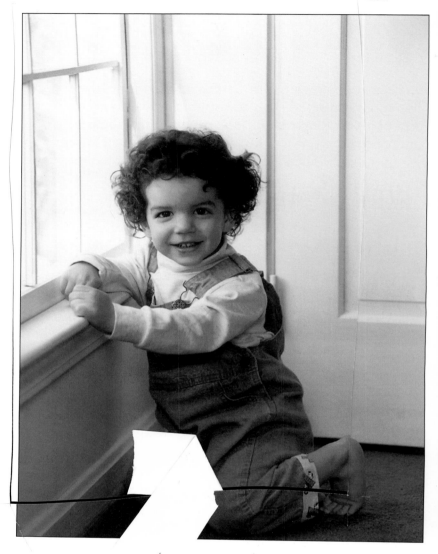

It is not unc___ ___ clients to send me thank you notes for the ext___ ___em. Some of the more up-front repeat clients, ___ ___ness executive, will ask what I am going to give ___ ___ time." The spouse usually elbows them and ___ ___ quiet. I laugh it off and say what I give the___ ___ didn't their mother ever teach them that it is tacky ___ ___ or a gift! They still know they are going to get something ___ ra… they just don't know what that extra is.

Part of the reason is laziness and part of the reason is fear. The laziness is human nature in that we are all just too busy to pick up the phone and make the call. I believe fear is the biggest inhibitor because we are so afraid that the client is going to say, "Oh, these pictures are so bad. I want my money back!"

Motivational speaker Zig Ziglar calls FEAR "False Evidence Appearing Real." Fear of calling is the perfect example. It is a ridiculous fear. The most likely response from clients is, "Oh, I love them so much. Everyone does! In fact, I need to order a couple of extra 8x10s for the relatives." Occasionally, there is a small problem. The frame doesn't match. The hand coloring is too light. The size is too big or too small. I would much rather fix the problem than wonder why the client never returned when I thought she was so happy.

That brings me to our unconditional guarantee. If the client is unhappy with any aspect of the portrait order, we will fix it.

Period. No questions asked. That means we will swap for a different frame or a larger or a smaller portrait size. We will add more hand coloring, or lighten what has already been done. We will also replace any portrait that has been damaged, even through gross negligence on the part of the client. (We are part of Eastman Kodak's Promise of Excellence program where Kodak guarantees any portrait created with Kodak film and printed on Kodak paper. For information, contact Kodak at (800)717-4040.)

Free shipping is another way we give our clients extra customer service. Since many of our clients live thirty minutes to two hours drive from our studio, we offer free delivery. During the fourth quarter of the year when the largest percentage of our work is completed, I schedule delivery days for various sections of our market area. I literally zig-zag my way up the eastern side of Massachusetts, wind my way through greater Boston and then zig-zag back down on the southern section. It is wonderful to see where the portraits are going to be displayed, and it is an extra way to show my clients that I care.

If it is not logistically possible to personally deliver the portraits, then we carefully pack them and ship via insured UPS. Again, there is no charge. Because our clients are willing to go out of their way to drive all the way to us for the photography session and again for the viewing, we feel like it is the least we can do to get the completed portraits to them as quickly and as easily as possible.

Keeping track of clients also means letting them know you appreciate their referrals. When anyone calls to inquire about our portraiture, I always ask, "How did you happen to call?" I jot down the referral name they give so I have it for future reference. Then I write a personal thank you note to the "old" client who referred me the "new." Each year there are several clients who refer me work left and right. To those folks, I send a special thank you gift at the end of the year. It might be my favorite box of chocolates that I have shipped in from Russell Stovers (orange jelly sticks!) or a jar of the Twenty-Four Kick peach salsa we ship in from Texas. The gift is a gesture to let these special folks know we appreciate their referrals.

When you keep track of your clients and treat them with extra TLC, you are creating clients who will return to you again and again. You are creating clients for life.

Delivery by Appointment

Many clients will come in to pick up their completed orders. We always ask people to call before they pick up their order because we want to make sure the final step is just as special as the beginning step. The client's portrait is displayed on a floor easel in the entry room so it is the first thing you notice when you open the front door. Smaller portraits are displayed on table easels nearby.

CLIENT FOLLOW-UP CARD

Name _____ Updated _____

Orig. referred by _____

Family Members Attach sample photo here:

Address _____

City/State/Zip _____

Home Business
Phone _____ Phone _____

Occupation _____ Spouse's Occupation _____

Portrait Style Client Likes:

Faces _____ Interacting _____ Soft _____ Canvas _____

Outdoors _____ Studio _____ Home _____ Casual _____ Formal _____

Boursier Portrait Summary:

Date	Type	Purchased	Total Sale

Boursier Follow-up:

Date	Reason	Response

Information Questions:

Education

High school and year _____

College _____

Military service _____ Discharge rank _____

Attitude about being in the service _____

Spouse's education _____

Hometown _____

Wedding Anniversary _____ How met? _____

Children's education _____

Children's interests (hobbies, problems, etc.) _____

What is his/her long-range business objective? _____

Special Interests

Clubs or service clubs (Masons, Kiwanis, etc.) _____

Politically active? _____ Active in community? _____

Religion _____

On what subjects does the customer have strong feelings? ____

Lifestyle

Hobbies and recreational interests _____

Vacation habits _____

Spectator-sports interest: sports and teams _____

Kind of car _____

Conversational interests _____

What adjective would you use to describe the customer? _____

What is he/she most proud of having achieved? _____

What do you feel is the customer's long-range personal objective? ____

What do you feel is the customer's immediate personal goal? ____

The Customer and You

Does the customer feel any obligation to you, your company, or your competition? ____

If so, what? _____

Is he/she primarily concerned about the opinion of others? ____

Or very self-centered? _____ Highly ethical? _____

Comments about future business possibilities:

To help us keep track of our clients, we use customer cards to record the names and ages of their children. I also jot down any personal notes that will be helpful to remember through the years. For example, one client attended the same prep school as our son. I won't always remember that detail, but she will remember it. I make a note of it on her card. I also jot down where my clients vacation, what special activities their kids participate in, how the couple met and how long they have been married and anything else personal that arises throughout normal conversation. Then, when a clients call to schedule their next session, I simply pull their cards and launch into the conversation as if we just chatted last week (instead of last year).

Chapter Twelve

The Eternal Second Act

Growing a business is just that: growing a business. You do not necessarily end up with what you set out to create. In fact, if you do keep things the same, your business will quickly wither and die. Our minister, Charlie Bark, once said, "Change is inevitable, but growth is an option." Changing your business to go with the flow and stay current with the ever changing times is a basic survival tactic every small business must endorse.

When we opened our original home studio in 1983 to photograph weddings using color film, Mike was the photographer and I was the assistant/production manager. We gradually added to and subtracted from our business as it slowly evolved to what it is today.

Now, we are one hundred percent hand colored black and white portraits of families and children. I am the full-time photographer and Mike is the assistant and production manager.

You don't necessarily need to know exactly what you want to be when you grow up, but you do need to have a loose idea of where you are going. Then, when you get a little farther down the road, you will be able to see farther still. Throughout all of the changing and growing, continue to add new products and services so you will have a little something different to offer your clients.

We added glamour photography so our brides would have a romantic portrait to give the groom. Then we added children's portraiture to accommodate our brides who went on to have babies. Then we added family portraits and high

school seniors. In the middle of all these portrait choices, we began offering black and white and hand colored black and white.

With all of these portrait styles scheduled on our job calendar, we realized we most liked photographing families and children. The next "bend" in the road was to gradually phase out of weddings and seniors while we expanded our families and children. As long as we were making changes, we also gradually phased out of offering color photography and fully into black and white and hand colored black and white.

With our "new" medium selected, we then looked for ways to expand our offerings. We gradually began offering larger and larger sizes. Instead of printing only 11x14 and smaller, we started offering all the way up to 30x40. Next we added black and white portraits on canvas to our product line. Canvas was traditionally offered only for color portraits, but we wanted to be able to offer this beautiful finish to our black and white clients too.

After studying mail order catalogs like Exposures and Ballard Design, we developed a line of matted and framed portraits so clients who wanted small portraits had a pretty way to display a grouping of several 8x10s and/or 5x7s. Within the framing line, we continually added and expanded products so our clients would have more choices.

"Watercolor portraits" became our next new addition. These portraits are totally different from our signature black and white style. We decided to let our clients decide whether this new look was something they wanted. Next we added a digital camera and a printer that can produce images up to 50" wide on watercolor paper or directly onto canvas.

Each new product required some experimenting. Each new line required some practice. Each new line required new samples. All these changes are part of the ebb and flow of growing a successful business. Never expect to cross into the end zone, spike the football and holler "touchdown!" The day you cross the finish line, throw up your hands and say, "I made it" is the day your business begins to die.

I had the privilege of creating the family portrait of motivational speaker Zig Ziglar for the "Thanks a Zillion Zig Tribute." While we were waiting for all of the family members to arrive at the Ziglar's Dallas home, we did the normal

One of a Kind Product

The more unique your product, the more you can charge. It is a simple law of economics. Part of your price is how unique or how mainstream you are. Even if your client selects one of your "normal" products, just the fact that you offer something incredibly creative, new and different tells the client you must be worth the money for all your products.

Left: My first black and white sessions were done on speculation. The client often did not even know I was doing a few images in black and white until she came to the studio to view the images. As I gradually made samples of hand colored black and white portraits, clients gradually began ordering black and white over color.

Below: Watercolor portraits give a painterly feeling to portraiture. This image looks like it was photographed in Europe, but it was taken at the Holiday Inn Express in Huntsville, Texas, while I was teaching at the Texas School of Photography.

back and forth small talk. Their home overlooks a golf course, and from listening to his lectures and reading his many books, I knew he had a passion for golf. I asked him how often he was able to play. I was surprised when he said he was lucky if he got out twice a month. He said no one loves the game of golf more than he does, but he just has too many projects that need to be finished. Instead of sitting back on the laurels of his reputation, this man in his 70s continued to pursue his dreams and goals and plans. He wasn't spiking the football in the end zone and yelling "Touchdown!" Like you and I should remember to do... he was continuing to make changes. Continuing to improve. Continuing to grow. As Zig is fond of saying, "Go as far as you can see and when you get

Using my remote control, I jumped in for the last picture of the Zig Ziglar family group.

APPENDIX

How to Make Black and

"Any 35mm non-automatic camera may be used."

Chromega C760 Color Head set at 25Y and 20M. The color head is upside down with an Omega 6x7cm negative carrier on top of the constant quartz light source. I use Print File (TM) #120-1M plastic sleeving, sold in a 1,000 foot continuous roll to protect the negatives. Then, slide the plastic sleeved negative across the light stand, copying each negative one at a time. For 6x6cm negatives (i.e. from square f

Because it has a very thin emulsion, all 150 feet will fit in the standard 100-foot bulk loader. You will get 42 rolls of 24 exposures from one bulk roll.

Technical Pan Film has increased red sensitivity, making it better for recording the details that are important for creating the slide proofs. The exposure on the camera is 1/125th at $f/11.5$ for studio shots and $f/11.25$ for outdoor images. The latitude of technical pan film is very tight, and a ¼ stop over or under is very noticeable. To determine your exposures, take a well-exposed negative and bracket. This test strip will ensure your own set-up gets consistent results.

Process the film normally for five minutes at 68 degrees in Kodak's HC-110 dilution B 1:31. The use of a high contrast developer like HC-110 looks much better for the projected images than a slower developer like Microdol or Kodak X-TOL (which I use for processing Tri-X with a 1:3 ratio). It is not necessary to fully wash the film since the slides are being used for a short-term time frame.

Technical Pan film dries very fast, so it is easy to quickly turn around the slide proof process. Once dry, mount the slides in Pakon™ plastic reusable slide mounts. Reusable, because after viewing you can throw away the slide part and mount another image for another client. We mark the bottom of the slides in pencil with the negative strip number and the frame number (i.e. 3-7 translates to strip number 3, frame number 7). To clean the slide mounts, simply use a kneadable eraser that you can find in art stores. Mounts can be ordered directly from Pakon Inc., (800) 367-9995; 1528 North Fulton Avenue, Evansville, Indiana 47710-2365; www.pakon.com or fax (800)286-8833. Slide mounts are available for the standard 35mm camera format, a slightly more square format (6x7 format) for the Mamiya RB format and the square format (6x6 format are 23mm by 23mm) for the Hasselblad or Mamiya C330 cameras.

INDEX

Other Books from
Amherst Media, Inc.

Basic 35mm Photo Guide
Craig Alesse

Great for beginning photographers! Designed to teach 35mm basics step-by-step — completely illustrated. Features the latest cameras. Includes: 35mm automatic, semi-automatic cameras, camera handling, *f*-stops, shutter speeds, and more! $12.95 list, 9x8, 112p, 178 photos, order no. 1051.

Wedding Photographer's Handbook
Robert and Sheila Hurth

A complete step-by-step guide to succeeding in the world of wedding photography. Packed with shooting tips, equipment lists, must-get photo lists, business strategies, and much more! $24.95 list, 8½x11, 176p, index, b&w and color photos, diagrams, order no. 1485.

Lighting for People Photography
Stephen Crain

The complete guide to lighting. Includes: set-ups, equipment information, strobe and natural lighting, and much more! Features diagrams, illustrations, and exercises for practicing the techniques discussed in each chapter. $29.95 list, 8½x11, 112p, b&w and color photos, glossary, index, order no. 1296.

Big Bucks Selling Your Photography
Cliff Hollenbeck

A complete photo business package. Includes secrets for starting up, getting paid the right price, and creating successful portfolios! Features setting financial, marketing and creative goals. Organize your business planning, bookkeeping, and taxes. $15.95 list, 6x9, 336p, order no. 1177.

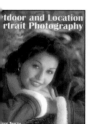

Outdoor and Location Portrait Photography
Jeff Smith

Learn how to work with natural light, select locations, and make clients look their best. Step-by-step discussions and helpful illustrations teach you the techniques you need to shoot outdoor portraits like a pro! $29.95 list, 8½x11, 128p, b&w and color photos, index, order no. 1632.

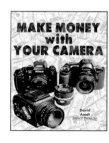

Make Money with Your Camera
David Arndt

Learn everything you need to know in order to make money in photography! David Arndt shows how to take highly marketable pictures, then promote, price and sell them. Includes all major fields of photography. $29.95 list, 8½x11, 120p, 100 b&w photos, index, order no. 1639.

Leica Camera Repair Handbook
Thomas Tomosy

A detailed technical manual for repairing Leica cameras. Each model is discussed individually with step-by-step instructions. Exhaustive photographic illustration ensures that every step of the process is easy to follow. $39.95 list, 8½x11, 128p, 130 b&w photos, appendix, order no. 1641.

Guide to International Photographic Competitions
Dr. Charles Benton

Remove the mystery from international competitions with all the information you need to select competitions, enter your work, and use your results for continued improvement and further success! $29.95 list, 8½x11, 120p, b&w photos, index, appendices, order no. 1642.

Freelance Photographer's Handbook
Cliff & Nancy Hollenbeck

Whether you want to be a freelance photographer or are looking for tips to improve your current freelance business, this volume is packed with ideas for creating and maintaining a successful freelance business. $29.95 list, 8½x11, 107p, 100 b&w and color photos, index, glossary, order no. 1633.

Infrared Landscape Photography
Todd Damiano

Landscapes shot with infrared can become breathtaking and ghostly images. The author analyzes over fifty of his most compelling photographs to teach you the techniques you need to capture landscapes with infrared. $29.95 list, 8½x11, 120p, b&w photos, index, order no. 1636.

Infrared Photography Handbook

Laurie White

Covers black and white infrared photography: focus, lenses, film loading, film speed rating, batch testing, paper stocks, and filters. Black & white photos illustrate how IR film reacts. $29.95 list, 8½x11, 104p, 50 b&w photos, charts & diagrams, order no. 1419.

The Art of Portrait Photography

Michael Grecco

Michael Grecco reveals the secrets behind his dramatic portraits which have appeared in magazines such as *Rolling Stone* and *Entertainment Weekly*. Includes: lighting, posing, creative development, and more! $29.95 list, 8½x11, 128p, order no. 1651.

Black & White Landscape Photography

John Collett and David Collett

Master the art of b&w landscape photography. Includes: selecting equipment (cameras, lenses, filters, etc.) for landscape photography, shooting in the field, using the Zone System, and printing your images for professional results. $29.95 list, 8½x11, 128p, order no. 1654.

How to Operate a Successful Photo Portrait Studio

John Giolas

Combines photographic techniques with practical business information to create a complete guide book for anyone interested in developing a portrait photography business (or improving an existing business). $29.95 list, 8½x11, 120p, 120 photos, index, order no. 1579.

Fashion Model Photography

Billy Pegram

For the photographer interested in shooting commercial model assignments, or working with models to create portfolios. Includes techniques for dramatic composition, posing, selection of clothing, and more! $29.95 list, 8½x11, 120p, 58 photos, index, order no. 1640.

Black & White Portrait Photography

Helen Boursier

Make money with b&w portrait photography. Learn from top b&w shooters! Studio and location techniques, with tips on preparing your subjects, selecting settings and wardrobe, lab techniques, and more! $29.95 list, 8½x11, 128p, 130+ photos, index, order no. 1626

Handcoloring Photographs Step-by-Step

Sandra Laird & Carey Chambers

Learn to handcolor photographs step-by-step with the new standard in handcoloring reference book. Covers a variety of coloring media and technique with plenty of colorful photographic example. $29.95 list, 8½x11, 112p, 100+ color and b& photos, order no. 1543.

Family Portrait Photography

Helen T. Boursier

Learn from professionals how to operate a successful portrait studio. Includes: marketing family portrait advertising, working with clients, posing, lighting and selection of equipment. Includes images from variety of top portrait shooters. $29.95 list, 8½x11 120p, 123 photos, index, order no. 1629.

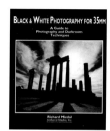

Black & White Photography for 35mm

Richard Mizdal

A guide to shooting and darkroom technique. Perfect for beginning or intermediate photographers who wants to improve their skill. Features helpful illustrations and exercises to make every concept clear and easy to follow. $29.95 list, 8½x11, 128p, order no. 1670.